IMAGES
of America

KEARNEY

IMAGES
of America

KEARNEY

ArLynn Leiber Presser with Rev. Michael Coglan
and Charles H. Seymour

ARCADIA
PUBLISHING

Published by Arcadia Publishing
Charleston SC, Chicago IL, Portsmouth NH, San Francisco CA

Printed in the United States of America

Library of Congress Control Number: 209943767

For all general information contact Arcadia Publishing at:
Telephone 843-853-2070
Fax 843-853-0044
E-mail sales@arcadiapublishing.com
For customer service and orders:
Toll-Free 1-888-313-2665

Visit us on the Internet at www.arcadiapublishing.com

*To our friends, old and new, from Kearney as well as our
families—most particularly: Laura, Joseph,
Eastman, Maximilian, and Edwin*

CONTENTS

Acknowledgments

Kearney is such a friendly place, such a welcoming community, that it is difficult to list all the people who gave their help to this project, and always with a smile and an encouraging word. For particular mention, the authors would be remiss not to acknowledge Mayor Bill Dane, fire chief Larry Pratt, police chief Tom Carey, village administrator Jim Eldridge, the Penrod Family, Elizabeth Ivy, Darryl McClung, Sara Przybylski of the State Historical Society of Missouri at Columbia, Elizabeth Beckett at the Jesse James Farm, as well as Amanda Coonce, Matt Carletti, and Michael Beckett of the Watkins Woolen Mill State Park and State Historic Site. The authors also thank our intrepid editors John Pearson and Anna Wilson. Unless otherwise noted, all photographs are courtesy of Charles H. Seymour.

INTRODUCTION

As American pioneers rushed westward, forward-thinking men and women saw the need for quick, dependable transportation to and from the East Coast. While travel from the North to the South and back again could be accomplished by boat along the Ohio, Missouri, Illinois, and Mississippi Rivers, railroads would be the man-made rivers to the West. New towns were built and older settlements were abandoned based on the proximity of the railroad. Missouri history changed forever when the railroad coursed through Hannibal on the eastern side of the state and west towards Kansas City, and it changed again when the need for a direct route from Chicago to Texas launched a north-south line through Kansas City.

Kearney was a loose settlement of farmers and ranchers until William R. Cave and David K. Duncan platted land in what is now the south edge of Kearney. They called it Centerville, possibly because it was in the center of Clay County. After the Civil War, in 1867, John Lawrence laid out a town half a mile north of Centerville and called it Kearney. There are conflicting theories of why he called it such. Perhaps he wanted to honor the town of Kearney, Nebraska, where he once lived—that town, in turn, had been named for General Stephen W. Kearny, who was long stationed in Missouri and played a significant role in the Mexican-American War. Under this theory, the addition of the second "e" in the name was a mistake on the part of a postmaster.

Another theory of the origins of Kearney's name is based on gratitude. To make sure that the area's products got to market, railroad access was essential. Charles Esmond Kearney (1820–1898), the first president of the Kansas City and Cameron Railroad, saw the need for a route linking Chicago and Texas. He persuaded fellow executives that the railroad should pass through Hannibal, thereby making Kansas City—and by extension Kearney—a major commercial player.

In any event, Kearney soon swallowed up Centerville, creating a solid little town devoted to ranching and farming. Churches, schools, and a downtown would follow, but already living in the area was a certain young man whose notoriety would haunt the town for the next century and a half.

One

A Troubled Son Born of Troubled Times

In the mid-1840s, settlers in the Kearney area were mostly those who had been driven from the Southeast by economic necessity. While owners of large plantations with sizable slaveholdings could withstand the vagaries of the cotton market, owners of the smaller farms could not. They moved west, looking for cheap land and an opportunity to provide for their families. They brought with them attitudes and ideas born of their Southern heritage: chivalry, love of the land, and an allegiance to the states that would ultimately break away to form the Confederacy.

Union sympathizers also settled in the area. The two groups were on a collision course that would decide the fate of the nation. It was a violent and troubling era. Nobody exemplifies this better than Kearney's most famous citizen—Jesse James.

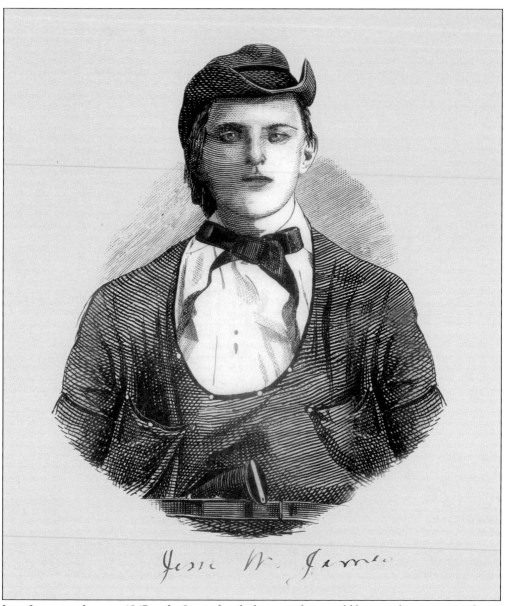

Jesse James was born in 1847 at the James family farm in what would become known as northeast Kearney. He was the third son of Robert and Zerelda James. Robert James was a hemp farmer and Baptist preacher and a founding member of William Jewell College in nearby Liberty. When Jesse was just three years old, Reverend James died in California where he had accompanied gold-seeking church members. His financial pledge to the college was ultimately honored by his sons, Frank and Jesse. (Courtesy of State Historical Society of Missouri—Columbia.)

Zerelda James was six feet tall, an extraordinary height for a woman of her time. After the death of her first husband and a brief second marriage to Benjamin Sims, which also ended in widowhood, she married 27-year-old Dr. Reuben Samuel, who gave up his medical practice to reside at the family farm. (Courtesy of State Historical Society of Missouri—Columbia.)

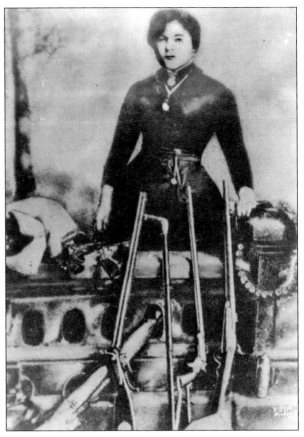

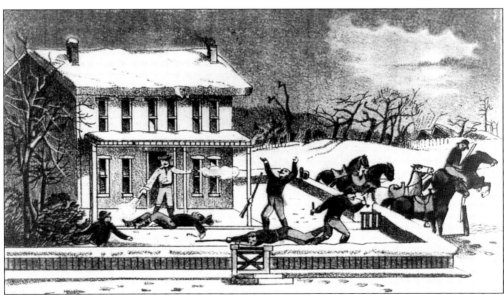

Zerelda and Reuben Samuel had four children, the last of whom—Archie—was killed in 1875 when Pinkerton detectives hoping to capture Jesse and Frank threw a bomb into the family home. The explosion also wounded Zerelda, and her right arm was amputated below the elbow.

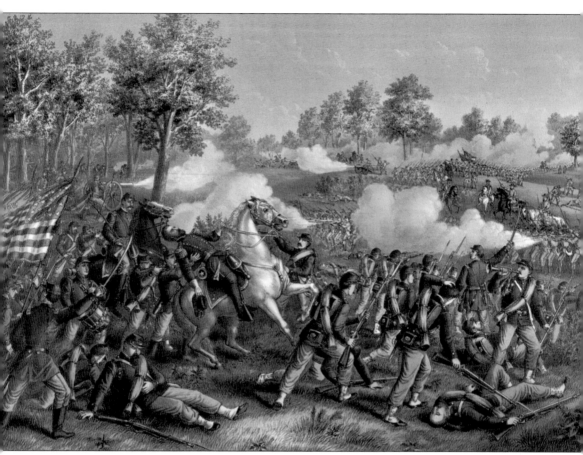

In 1854, the Kansas-Nebraska Act allowed for residents of these two territories to vote for their territory to be established as a "free" or "slave" state. Southern sympathizers crossed over from Missouri to persuade the voting population. Violence erupted, earning Missouri's neighbor the nickname "Bleeding Kansas." Many residents of Kearney were strongly sympathetic to the South, so much so that the area acquired the nickname "Little Dixie." Zerelda and Reuben owned as many as seven slaves. Reuben may have been the father of Perry Samuel, born to one of those slaves and later adopted by Zerelda. Frank fought for the Confederate Army at the Battle of Wilson's Creek, which this lithograph commemorates. (Courtesy of State Historical Society of Missouri—Columbia.)

Frank, pictured here, later joined the gang of William Quantrill. The Quantrill Raiders tore through Lawrence, Kansas, in 1863, robbing two banks, looting homes and businesses, and killing over 150. Jesse later bragged about being part of this attack, but this may have been an exaggeration. (Courtesy of State Historical Society of Missouri—Columbia.)

In May 1863, Union soldiers sought Frank James in connection with the Quantrill Raiders. They attacked the James family farm, whipping 15-year-old Jesse and repeatedly hanging Reuben (left) from a tree. Miraculously, Reuben survived. Jesse's heart hardened against Northerners. (Courtesy of State Historical Society of Missouri—Columbia.)

13

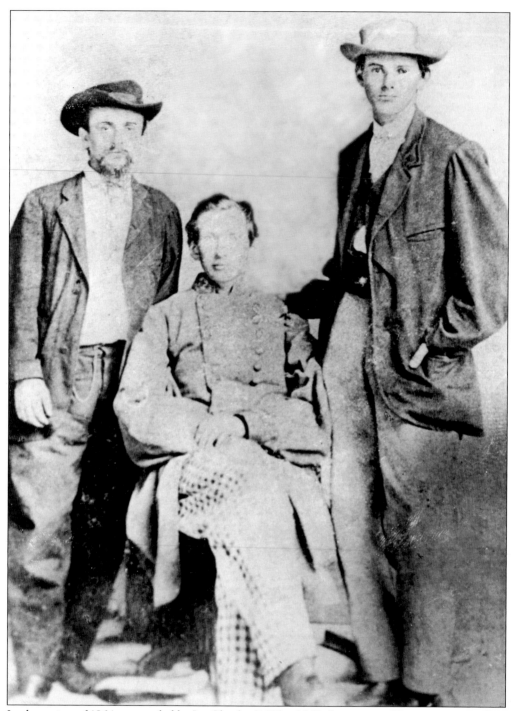

In the spring of 1864, a party led by Lt. Charles F. "Fletch" Taylor recruited Jesse to join a militia aligned with the Confederate Army. Frank and Jesse participated in a raid on Centralia, Missouri, in which over 120 Federal troops were massacred. Jesse was credited with killing Maj. A. V. Johnson and seven other men. Here, Taylor (seated) poses for a picture with the James brothers. (Courtesy of State Historical Society of Missouri—Columbia.)

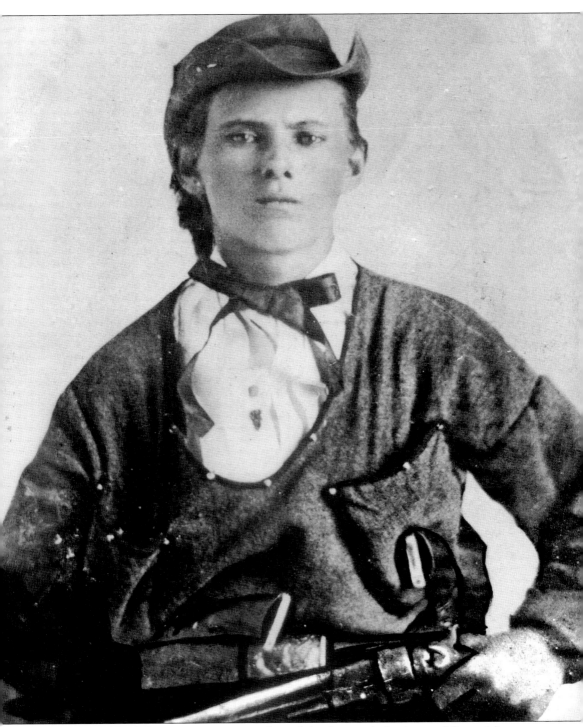

In 1865, possibly while attempting to surrender to federal troops in Lexington, Missouri, Jesse was shot in the chest. He crawled to safety, a bitter teenager. His cousin Zerelda "Zee" Mimms, who was named for his mother, tended to his wounds. The ensuing nine-year courtship resulted in marriage between the two cousins. (Courtesy of State Historical Society of Missouri—Columbia.)

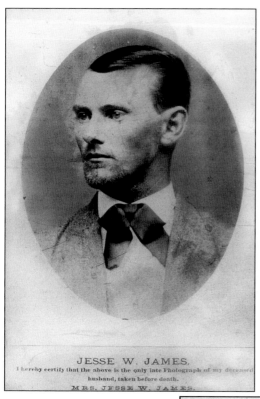

JESSE W. JAMES.

I hereby certify that the above is the only late Photograph of my deceased husband, taken before death.

MRS. JESSE W. JAMES.

In 1866, Frank joined Cole and Jim Younger and nine other men to rob the Clay County Savings Bank in Liberty. Nineteen-year-old William Jewell College student George "Jolly" Wymore was shot and killed as they retreated. Jesse joined the group and became its public face as several lucrative robberies followed. Though newspaperman John Newman Edward glorified the gang's exploits as having a Robin Hood-like quality, there is no evidence that Jesse or any other gang member used his ill-gotten gains to do good. The gang carried out a string of robberies throughout the country. (Courtesy of State Historical Society of Missouri—Columbia.)

In 1876, the James-Younger gang attempted a raid on the First National Bank of Northfield, Minnesota. Bank cashier Joseph Lee Haywood and recent immigrant Nicholas Gustafson were both killed. The former refused to cooperate with the gangsters, and the latter probably did not know enough English to understand the gang's directives. The deaths of Haywood and Gustafson are commemorated every summer at a graveside service in Northfield City Cemetery. Cole Younger (right) and his brothers were ultimately captured and imprisoned. (Courtesy of State Historical Society of Missouri—Columbia.)

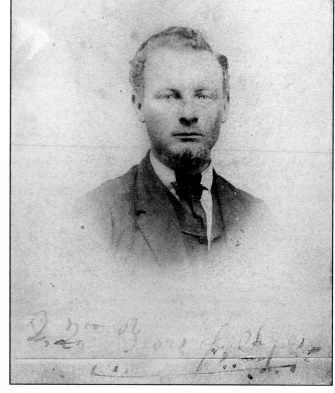

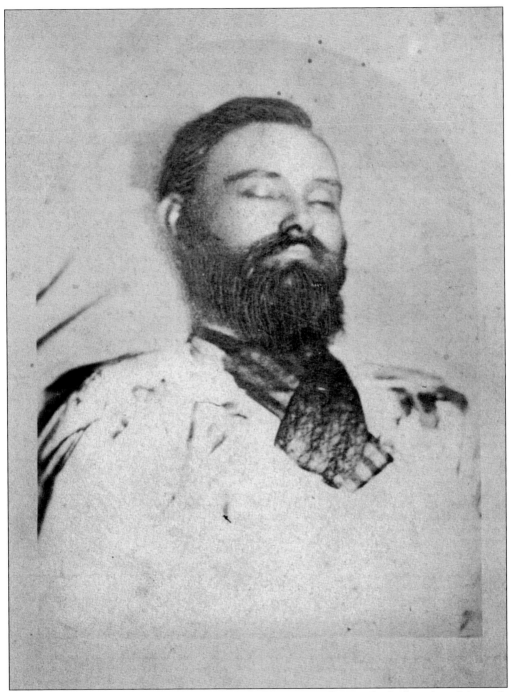

The gang dispersed. Frank moved to Virginia, and Jesse moved to nearby St. Joseph with his wife and two children. Jesse enlisted Charley and Robert Ford to stage one last robbery in 1882. He did not know that the Fords had negotiated with Gov. Thomas T. Crittenden to bring Jesse to justice. While Jesse stood on a chair to clean the dust from a picture hanging in his living room, Robert Ford shot him in the back of the head. Jesse died instantly. (Courtesy of State Historical Society of Missouri—Columbia.)

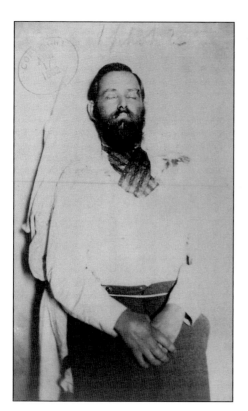

Jesse's murder was a national sensation. A crowd gathered at the St. Joseph home to gawk and photograph his body. The Fords, surrounded on all sides by onlookers, surrendered to authorities. The brothers were surprised to be charged with first-degree murder instead of receiving the reward they thought they were owed.

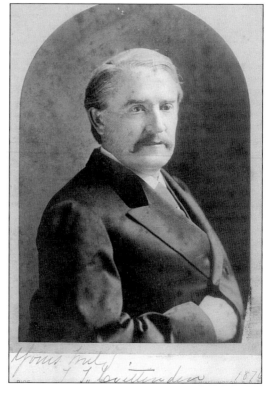

The Fords were indicted, pled guilty, were sentenced to death, and then were granted a full pardon by Governor Crittenden (right)—all in the course of one day. Later, the Fords fled Missouri, at one point joining a touring stage show in which they reenacted the shooting. Charley Ford committed suicide in 1884. Eight years later, Edward O'Kelley shot Robert Ford dead in a Colorado bar. (Courtesy of State Historical Society of Missouri—Columbia.)

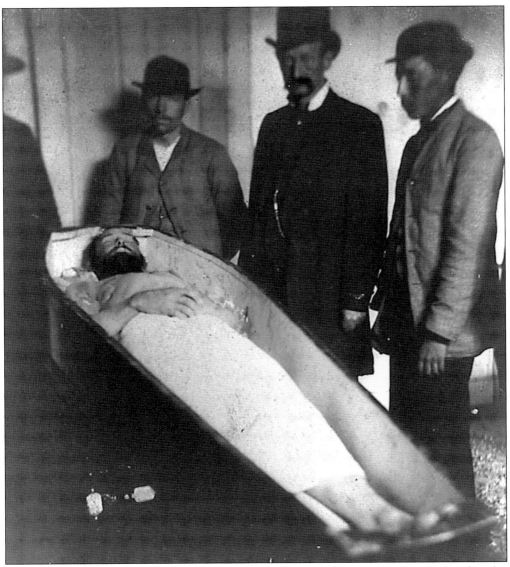

Jesse's body arrived in Kearney by train at 2:30 a.m. the next morning and was displayed to the crowd waiting at the station. Over 1,000 people would view the body, including from the windows of passing trains. His mother, Zerelda, ordered that his body be buried in the James's farmhouse yard after a protracted funeral at the Baptist Church where Jesse had for so many years sung in the choir. From the front porch of the family home, she watched over the body for 10 years and charged visitors to approach the grave and take pebbles from it. The epitaph read, "In Loving Memory of My Beloved Son, Murdered by a Traitor and Coward whose Name is Not Worthy to Appear Here." Jesse's widow, Zee, died alone and in poverty in 1900.

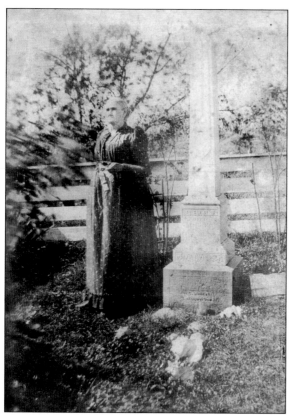

In 1902, Zerelda ordered Jesse's body moved to the Mount Olivet Cemetery. There are conflicting stories that she did so because she wanted Jesse to be buried beside his recently deceased widow or because Zerelda had become convinced that someone had stolen her son's body. When it was exhumed, the casket had deteriorated and the body was held together by its burial suit. Nonetheless, Jesse James Jr. positively identified the corpse as his father's by the bullet wound at the back of its skull. The body was reinterred at Mount Olivet Cemetery under a five-foot tall headstone. (Courtesy of State Historical Society of Missouri—Columbia.)

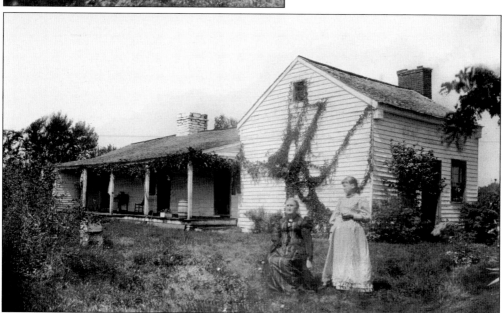

Zerelda died in 1911 at the age of 86 while on a train returning from a visit to her son Frank and his wife, Annie, in Oklahoma. She was buried near her third husband and sons Jesse and Archie. Zerelda is pictured here with her granddaughter Mary at the family farm. (Courtesy of State Historical Society of Missouri—Columbia.)

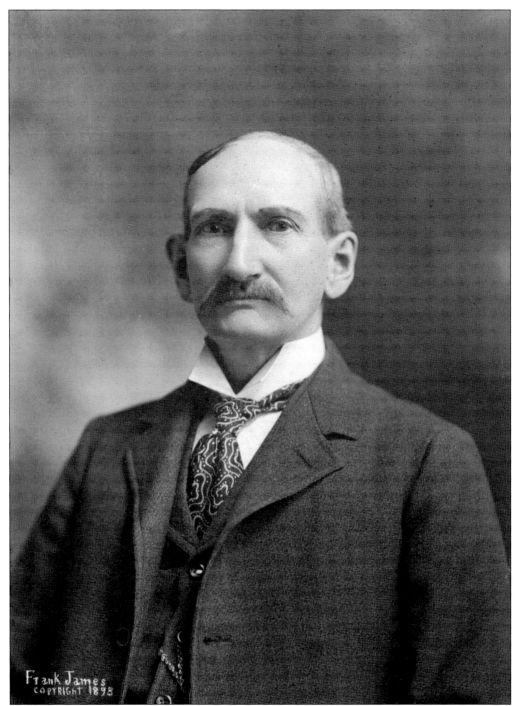

Frank James
COPYRIGHT 1898

With the understanding that he would not be extradited to Northfield, Minnesota, Frank James returned to Missouri five months after his brother Jesse's death. He met with Gov. Thomas Crittenden, reportedly stating, "I have been hunted for 21 years, have literally lived in the saddle, have never known a day of perfect peace. It was one long, anxious, inexorable, eternal vigil." (Courtesy of State Historical Society of Missouri—Columbia.)

Frank was tried and acquitted twice of the robberies and murders of which he was accused. He died in 1915 at the age of 72. He asked that his body be cremated and kept in a bank vault until he could be buried alongside his widow, Annie Ralston James. After she died in 1944, their ashes were buried together in Independence, Missouri.

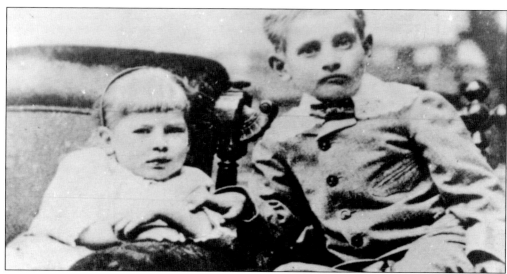

Jesse and Zee James had four children together, two of whom died in infancy. At his death, in addition to his wife, Zee, Jesse left behind his daughter, Mary, and son Jesse Jr., pictured here just before their father's death. Jesse Jr. sold pebbles from the grave of his father to visitors for $1 each. Both children later appeared in the 1921 movie *Jesse James Under the Black Flag.* (Courtesy of State Historical Society of Missouri—Columbia.)

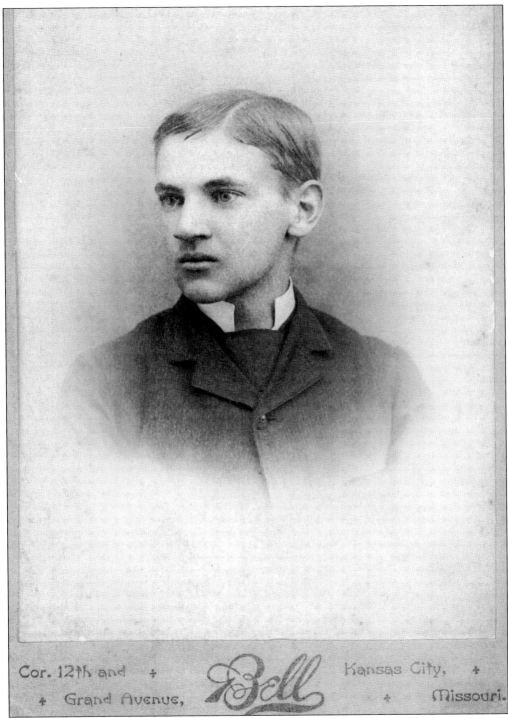

Jesse Jr. sometimes went by the name "Tim Edwards" to conceal his relationship to his father. He would become a respected attorney in Los Angeles, California. In addition to the movie *Jesse James Under the Black Flag*, Jesse Jr. also appeared in *Jesse James as an Outlaw*. He also wrote *Jesse James, My Father*, published in 1899. (Courtesy of State Historical Society of Missouri—Columbia.)

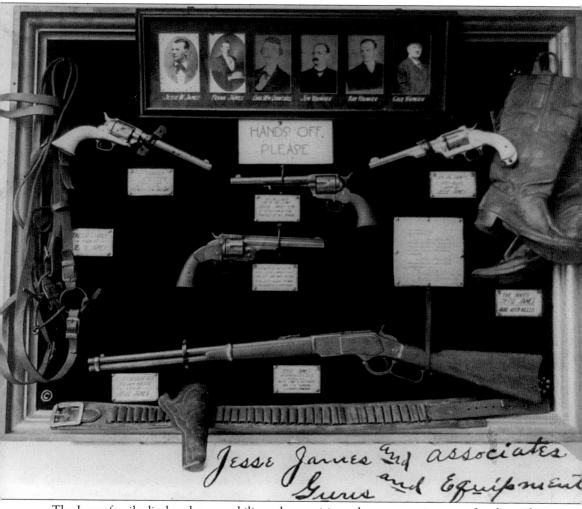

Jesse James and associates Guns and Equipment

The James family displayed memorabilia and gave visitors the opportunity to see family artifacts for many years. Rumors persisted that Robert Ford had killed a "stand-in" and Jesse had survived his assassination. In 1948, 103-year-old J. Frank Dalton declared that he was Jesse James and that the body buried at Mount Olivet was that of fellow gang affiliate Charlie Bigelow. Dalton claimed that all parties with knowledge of the "switch" had sworn an oath to not reveal anything until they turned 100 years old. The 103-year-old Dalton's story, however, did not stand up to questioning from surviving James family members.

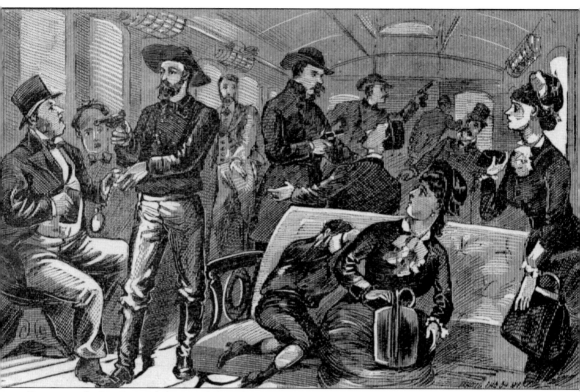

During and after Jesse's lifetime, defeated Southerners regarded him as a populist hero. Here a newspaper illustration depicts the robbery of a train at Gad's Hill. Jesse James was said to have been a chivalrous robber who never took money from women or the poor. Note the apparently wealthy man giving up his pocket book and watch to James while the women and children are left unmolested. (Courtesy of State Historical Society of Missouri—Columbia.)

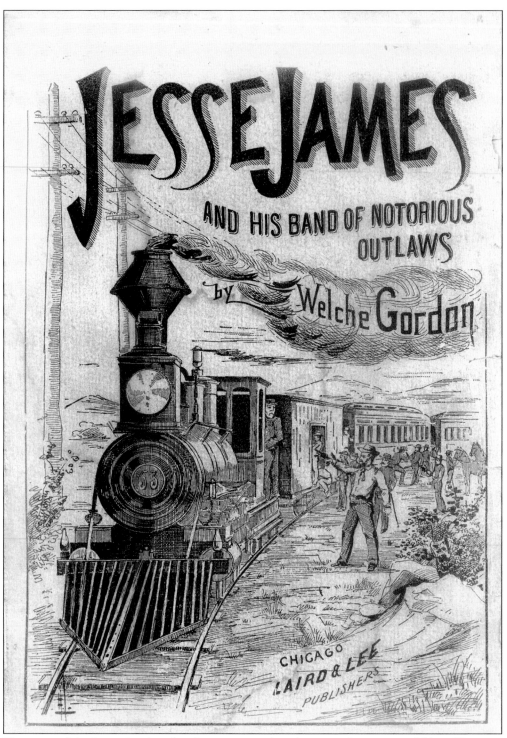

The story of the James brothers has been portrayed in dime novels, songs, and films. Here is a copy of the Welche Gordon novel *Jesse James and His Band of Notorious Outlaws*. (Courtesy of State Historical Society of Missouri—Columbia.)

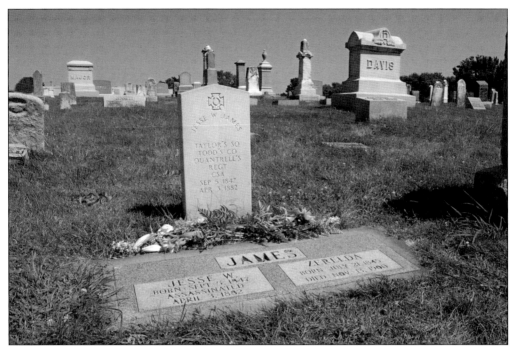

Visitors to Jesse's grave at Mount Olivet scraped off pieces of the gravestone until its engraving was unreadable. In 1960, surviving family members agreed to replace it with a modern marker set flush to the ground.

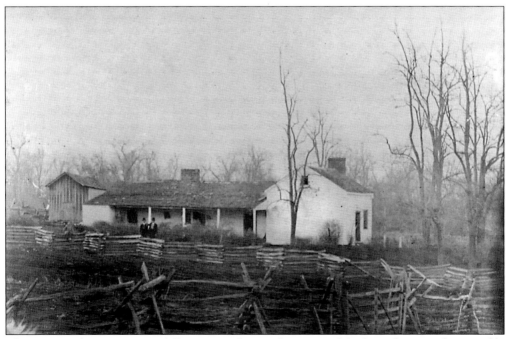

Chicago speculators unsuccessfully attempted to purchase part of the James house and reassemble it at the 1893 Chicago World's Fair. Though the family hoped to make money from their legacy, they were often exploited.

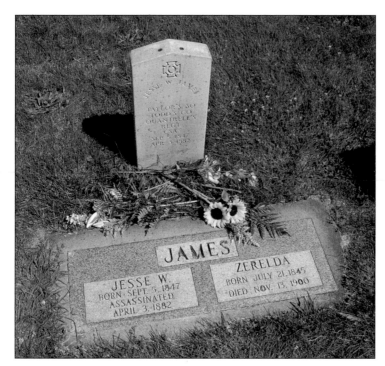

Jesse was exhumed in 1995, and DNA analysis established with 99.9 percent accuracy that the body buried at Jesse's grave is a James family member. A headstone commemorating James' service to Quatrell's (sic) Regiment is displayed in back of the stone, as is common for Confederate soldiers. Even today, visitors leave flowers and pennies atop Jesse's grave.

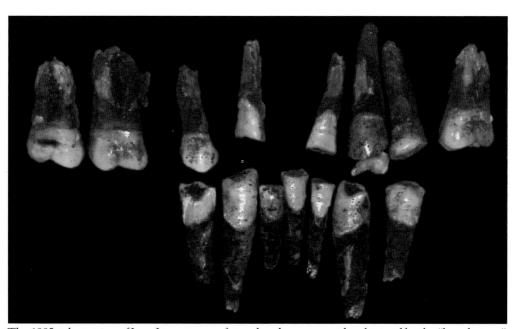

The 1995 exhumation of Jesse James was performed under a court order obtained by the "bonehunter" team of Anne Stone, James Starrs, and Mark Stoneking. The team used mitochondrial DNA analysis on remains of Jesse James recovered both from the body buried at Mt. Olivet Cemetery and from hair and bone fragments obtained from the James Farm. Pictured here are decayed teeth fragments. Kearney's chapter of the Knights of Columbus gave the remains a suitably formal reburial. (Courtesy of Dr. James McDowell, D.D.S.)

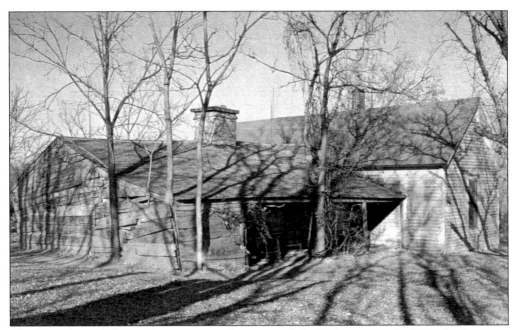

The James home fell into disrepair over the course of the 20th century. In 1978, the farm was purchased by Clay County and restored as a museum. A replica of the original tombstone was built and placed where Jesse was originally buried. (Courtesy of the Kearney Historical Society.)

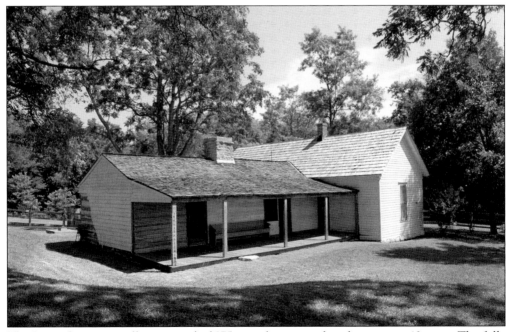

The James farm originally consisted of 275 acres but was reduced to a mere 40 acres. The fully restored house is open to the public and is a popular destination, particularly during Kearney's annual Jesse James Festival held each September.

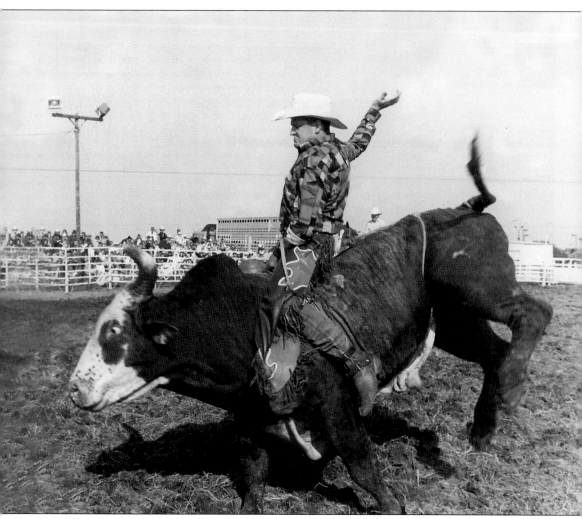

Although Jesse and Frank James were certainly robbers and murderers, citizens of Kearney understand the rugged and vibrant spirit associated with the James mythology. Each September, that spirit is celebrated with a parade, rodeo, dances, and concerts during the annual Jesse James Festival. Here a bull rider endures what is widely regarded as "the most terrifying eight seconds in sports."

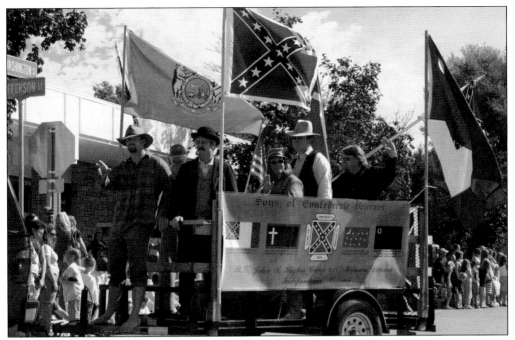

The Jesse James Festival's Saturday morning parade always brings together a diverse group of people. In this photograph, T. Hughes Camp 614, Missouri Division of the Sons of the Confederate Veterans (from nearby Independence) displays the Confederate "Blood-Stained Banner" flag, the Missouri Confederate Battle Flag (with its blue field and single white cross), and the Black Flag of the Quantrill Partisan Rangers, for which both Frank and Jesse James fought.

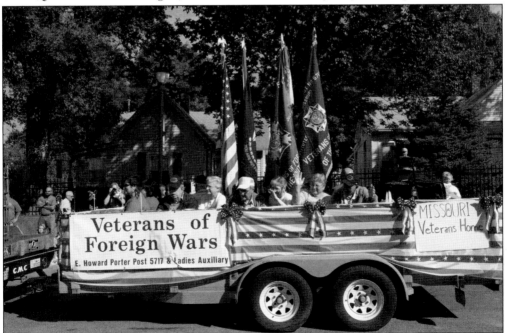

The Veterans of Foreign Wars members of the E. Howard Porter Post 5717 and its Ladies Auxiliary honor and represent local residents who served in the armed services overseas.

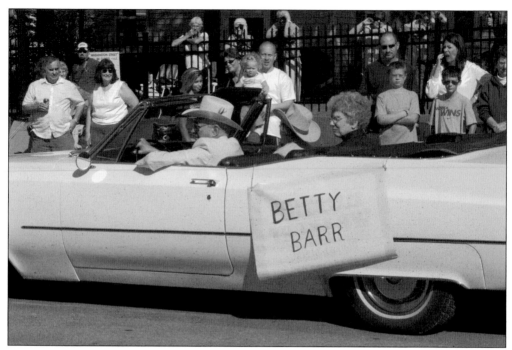

Betty Barr—granddaughter of Jesse James—rides in the parade in Kearney's 2009 Jesse James Festival.

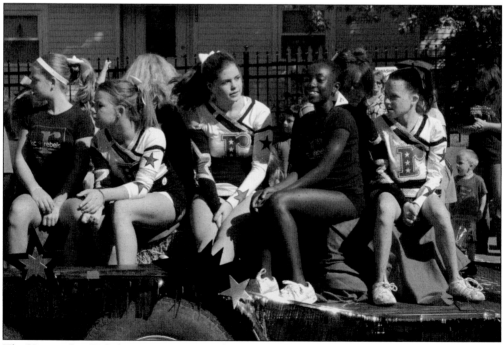

The Kansas City Rebels compete in pom, dance, and cheerleading. They enliven the Jesse James Festival parades with rebel cheers and routines. Their values are "honesty, persistence, determination, integrity, and dedication." This spirit is a part of Kearney's history and its future.

Two

THE WATKINS UTOPIA

While the story of the James brothers and their outlaws is exciting, another story—less dramatic but no less compelling—was being written at the same time that the James boys were gunning their way into Western mythology. Despite the troubled times faced by Missourians in the 19th century, many immigrants quietly pushed ahead to carve out livelihoods, raise families, and establish communities.

The best example of this is the story of Waltus Watkins, whose farm was just a short walk from Jesse James' home. Taking advantage of the need for inexpensive textiles during the Civil War and capitalizing upon the increased efficiencies of the Industrial Age, Watkins' story is a tale of success over adversity and of a determination to find peace in a troubled land.

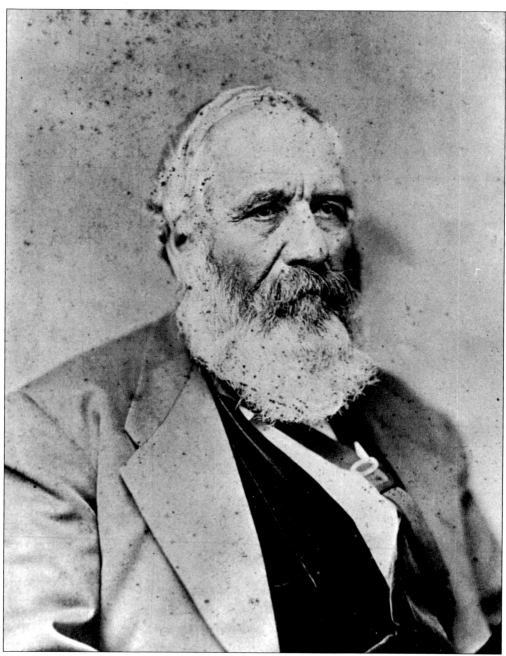

Born in 1806 in Kentucky, Waltus L. Watkins moved to Liberty, Missouri. When he discovered that raising cotton was unprofitable, he set up a wool-carding mill—which burned to the ground. But Watkins was a determined man. In 1839, he purchased land just outside of what would become Kearney. He would ultimately preside over a gristmill, brick kiln, three sawmills, a woolen mill, and a 3,600-acre farm. Waltus helped found a school and a church that served his employees and neighbors. (Courtesy of the Missouri Department of Natural Resources, Watkins Woolen Mill State Park and State Historic Site.)

In 1834, Watkins brought his bride, Mary Ann Holloway, from her Kentucky home. She would bear 11 children, 9 of whom survived childhood. She and Waltus called their home Bethany after the town that was home to New Testament siblings Mary, Martha, and Lazarus and from which the Gospel of Luke reports that Jesus ascended into heaven. (Courtesy of the Missouri Department of Natural Resources, Watkins Woolen Mill State Park and State Historic Site.)

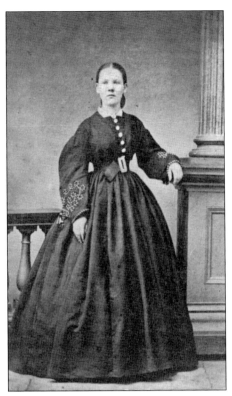

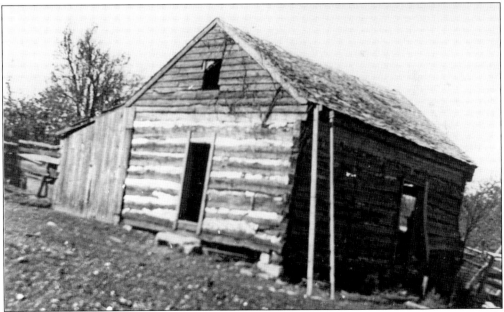

The first years at Bethany were difficult, and the family lived in a two-room cabin. The family added a lean-to and a sleeping loft. Living with the couple in the cabin were Waltus's mother, his sister Rebecca, and the Watkinses' eight children (two of whom passed on while the family lived in the cabin). (Courtesy of the Missouri Department of Natural Resources, Watkins Woolen Mill State Park and State Historic Site.)

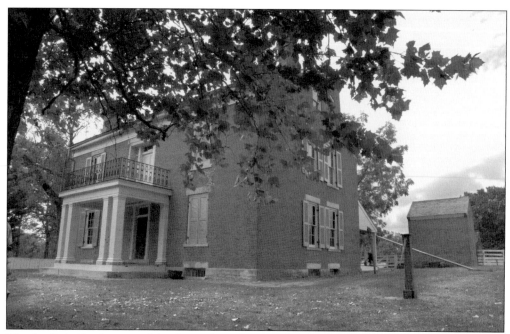

The family built a home with bricks made at their own kilns. The winding front staircase leading to the master and guest bedrooms was made of native walnut and apparently delayed completion of the project for two years. The home was capable of housing the couple, their children, their farmhands, Waltus's mother, his sister Rebecca, and a steady stream of guests.

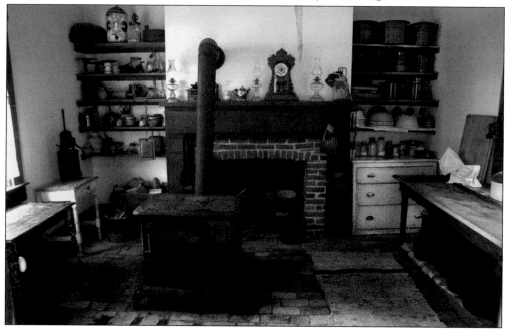

For nine months of the year, the family's kitchen was housed in an adjacent building behind the home. During the winter months, the kitchen's contents (including the stove) were moved into the house. As the single dining room could not accommodate all of Bethany's inhabitants, dinner generally involved three seatings. The men ate first, the children second, and the women last.

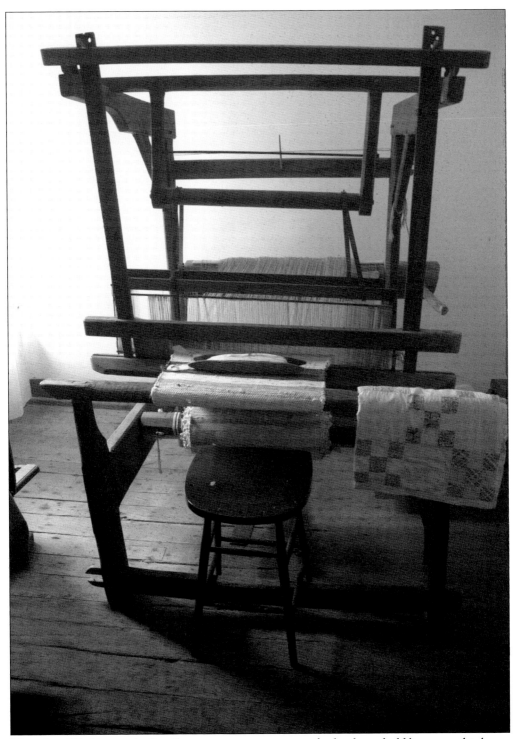

Mary Ann Watkins used a first-floor room to weave rugs and other household linens on this loom. During the winter, the loom was disassembled and the room was converted into a kitchen. Mary Ann's day began well before dawn, and more work always awaited her.

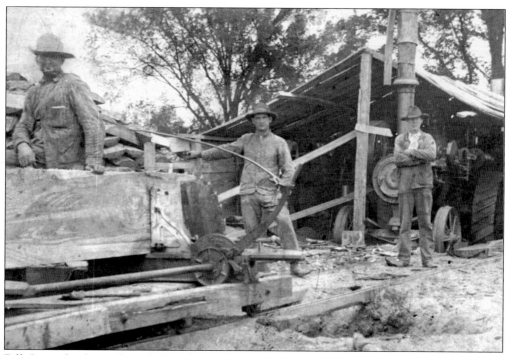

Bill Cavender (center) worked at the Bethany sawmill, and his family lived on the Watkins property. The Cavender cabin, along with so many other buildings, was lost during the late 19th or early 20th century and has not been restored. (Courtesy of the Missouri Department of Natural Resources, Watkins Woolen Mill State Park and State Historic Site.)

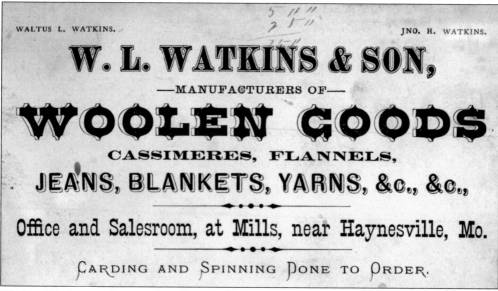

Watkins's background in textile mills served him well, and the new railroads helped his growing business. The woolen mill produced a quality line of fabrics, blankets, fine yarns, and batting that was shipped as far away as Chicago. The mill operated roughly nine months of the year. (Courtesy of the Missouri Department of Natural Resources, Watkins Woolen Mill State Park and State Historic Site.)

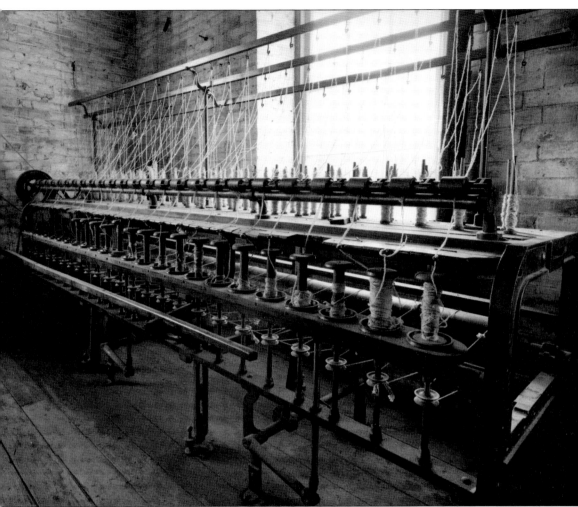

During the Civil War, the need for woolen products increased dramatically, and the Watkins family prospered. Son John H. Watkins and his brothers would continue to operate the factory after their father's death. A look at textile prices tells the story of the family's rise and decline: in 1862, the price of cotton flannel was 60¢ a yard; by 1865, the same flannel was selling for 90¢ a yard. By the end of the 1870s, eastern cotton producers' ability to charge just 35¢ a yard virtually priced the Watkins family out of the market. (Courtesy of the Missouri Department of Natural Resources, Watkins Woolen Mill State Park and State Historic Site.)

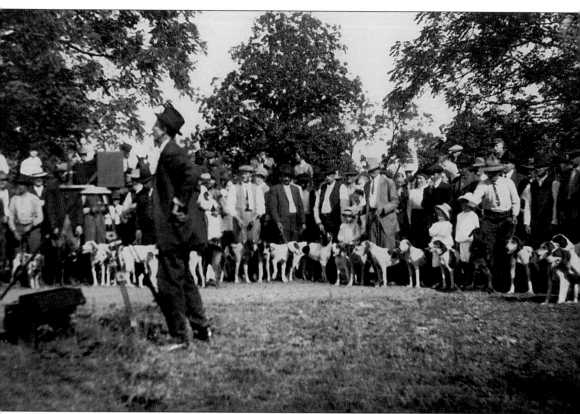

Although he himself did not enjoy fox hunting, Waltus's son John Watkins hosted the annual meeting of the Missouri Valley Fox Hunters Association from 1909 until his death in 1939. Hunters and spectators would erect as many as 140 tents on the Watkins property, along with a movie theater, restaurant, barbershop, and other structures. In some years, an estimated 20,000 people came to participate and to watch. Here a photographer prepares to create a panoramic portrait to commemorate the beginning of the hunt. (Courtesy of the Missouri Department of Natural Resources, Watkins Woolen Mill State Park and State Historic Site.)

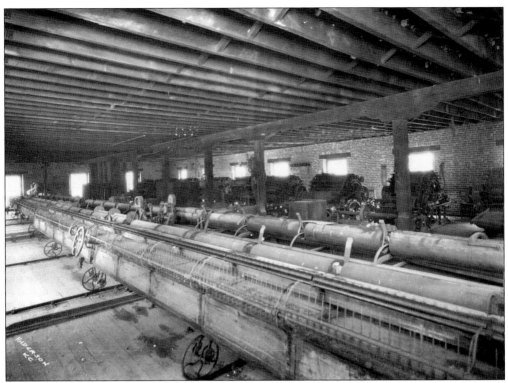

The wool mill employed approximately 40 people at its height of production. After the Civil War, demand for wool decreased, and by the 1880s the mill was struggling. (Courtesy of the Missouri Department of Natural Resources, Watkins Woolen Mill State Park and State Historic Site)

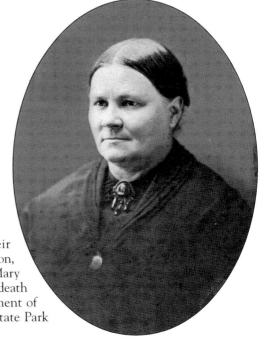

In 1882, Waltus and Mary Ann sold their landholdings in Clay County to their sons Judson, Joe, and John. After Waltus's death in 1884, Mary Ann remained in the family home until her death in 1896. (Courtesy of the Missouri Department of Natural Resources, Watkins Woolen Mill State Park and State Historic Site.)

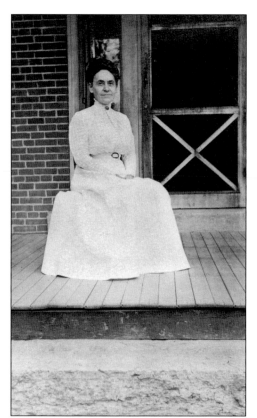

After Mary Ann's passing, her daughter Caroline ("Carrie"), pictured here, and sons John and Joe remained in the home. In 1899, Joe Berry Watkins married Ina Goddard. She lived in Missouri for approximately six months before returning back east. They stayed married for 10 years while living in separate locations until they were finally divorced in 1910. Carrie later became blind and studied Braille. (Courtesy of the Missouri Department of Natural Resources, Watkins Woolen Mill State Park and State Historic Site.)

Waltus Watkins's brother-in-law John G. Handy gave the Watkinses financial support in order to help them get their farm and businesses started. He may have done some of the woodwork in the Watkins home. (Courtesy of the Missouri Department of Natural Resources, Watkins Woolen Mill State Park and State Historic Site.)

The property changed hands several times until 1964, when it became a Missouri State Historic Site. In 1966, it attained the status of National Historic Landmark. In 1981, Missouri voters approved a bond that called for the improvement of state buildings, which included the Watkins Mill and Farm. The Visitors Center was added in 1991. Restoration has included furniture such as the standing desk pictured here on the second floor landing, from which Watkins could survey his mills and lands.

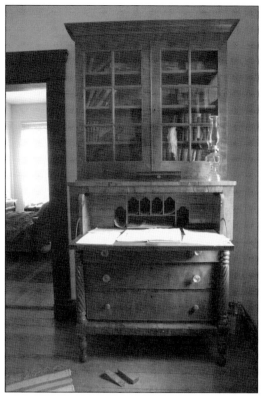

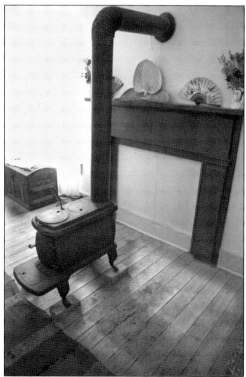

Waltus had definite ideas about his home. Regarding wood stoves as more efficient than fireplaces but liking the look of a mantle, he combined the two. Only two working fireplaces were installed in the house—in the family room and in his mother's room.

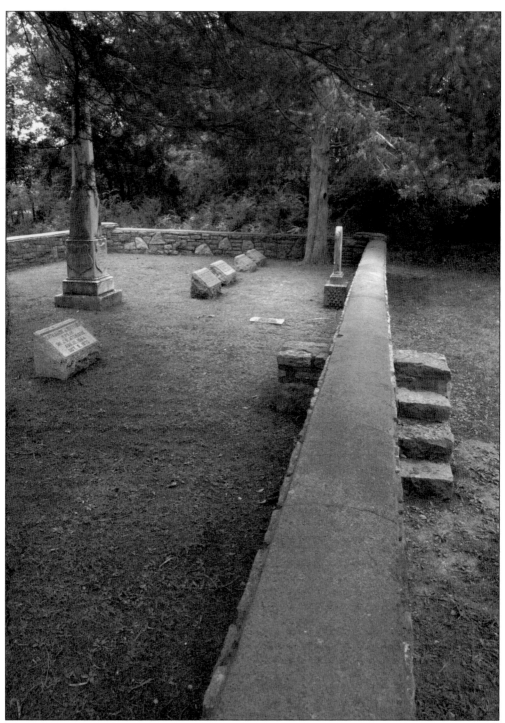

Near the Watkins home is a family cemetery. Waltus Watkins (1806–1884); Mary Ann Watkins (1817–1896); his mother, Jane Minter Watkins (1781–1862); his sister Rebecca Watkins Yates (1821–1885); daughter Catherine Jane "Kate" Watkins (1844–1870); sons John Handy Watkins (1841–1931) and Joe Berry Watkins (1859–1933) are buried there.

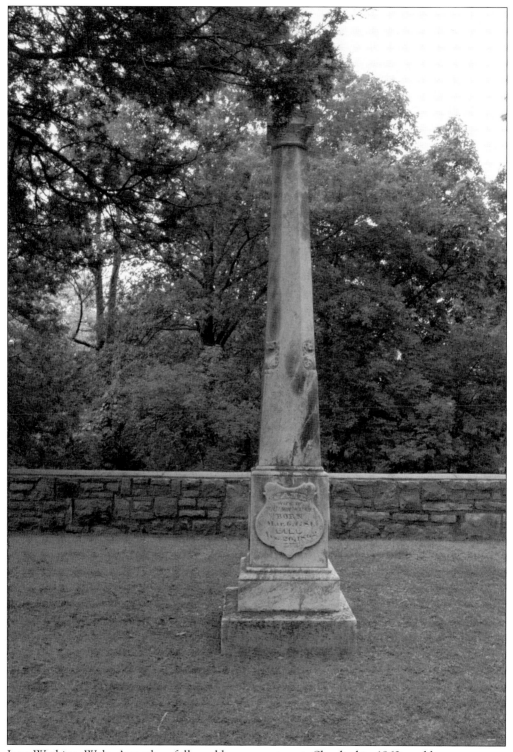

Jane Watkins, Waltus's mother, followed her son out west. She died in 1862, and her gravestone is the tallest in the family cemetery.

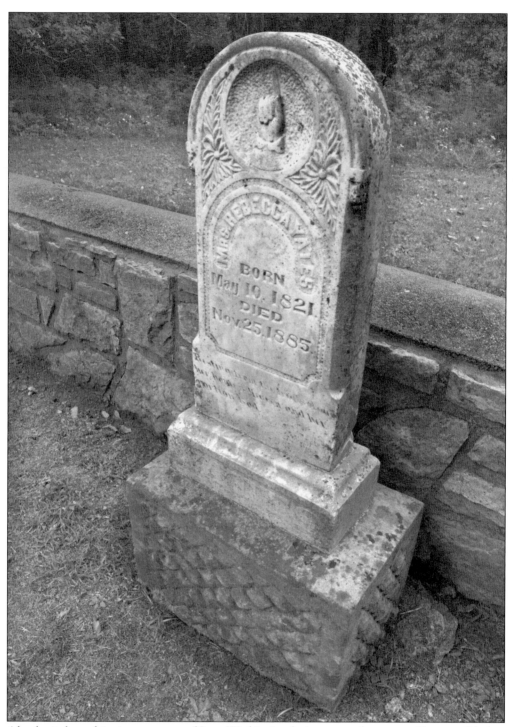

MRS. REBECCA YATES
BORN
May 10, 1821
DIED
Nov. 25, 1885

Also buried on this site are some of Jane Watkins's relatives: a nephew, as well as possibly her brother, his wife, and as many as five children. Sons John Holloway Watkins (1835–1839) and Alfred Watkins (1839–1840) passed away before the cemetery was established. Modern curators are still unable to ascertain where these two are buried.

Three

Not Quite
a Troubled Son,
Not Quite a Utopia

While Jesse James and Waltus Watkins represent two extremes of the people who settled in Kearney, the vast majority of people were neither sinners nor saints. After the Civil War, the land was quickly appropriated for farming and ranching. Kearney could not have survived without the railroad, which transported grain and cattle to market and brought to Kearney the equipment and retail products it needed.

While many failed to survive in the rugged conditions of western Missouri, a handful of families thrived. Their horses needed to be shod, their tractors needed to be repaired, and their money needed a safe place to be deposited. From these needs, a town was born, and it was centered around the train depot.

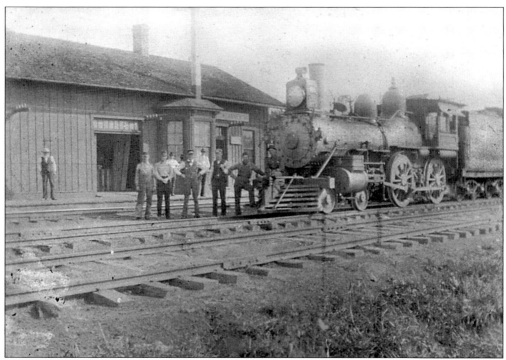

In 1867, the railroad was built from nearby Harlem through Kearney to the Cameron Branch of the Hannibal and St. Joseph Railway, later called the Burlington Railroad. The town was most likely named for Charles Esmond Kearney, the first president of the Kansas City and Cameron Railroad. (Courtesy of Kearney Historical Museum.)

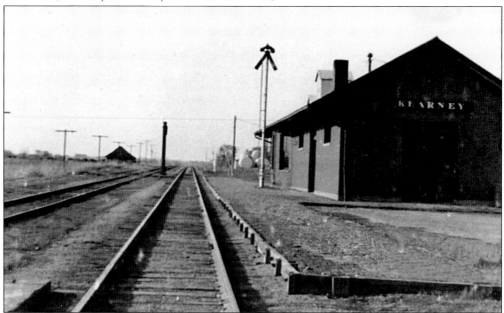

Charles Kearney saw the need for a direct link from Chicago to Texas, making Kansas City—and by extension, Kearney—a major commercial player. Without the railroad, Kearney would not be able to bring its grains and its cattle to market. (Courtesy of Kearney Historical Museum)

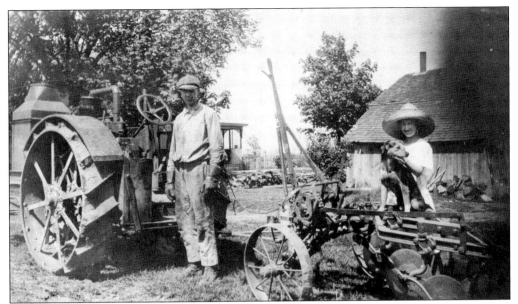

Common wisdom holds that land to the west of the town is rich enough to support farming while the east side of town is best suited for raising cattle. Some families managed to raise cattle as well as till the land: here Floyd Hessel and his sister Flora pose with their dog Gippie in 1919. (Courtesy of Elizabeth Ivy.)

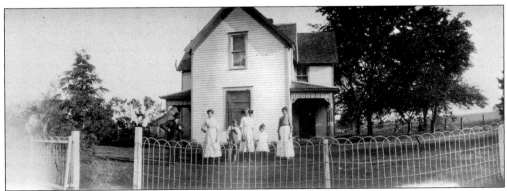

Many of the early settlers in Kearney were of German heritage. Herman Hessel (pictured at left) brought his family to Kearney in the late 1880s, little realizing that he would found a dynasty that would prosper into the 21st century. (Courtesy of Elizabeth Ivy.)

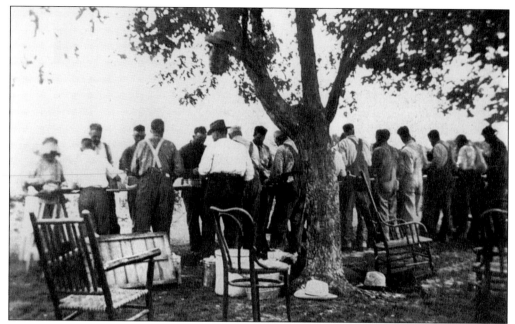

Kearney neighbors helped each other at every stage of the farming process, but a crew of neighbors required food. In this photograph, men who have helped with threshing take their meal standing at a table laid on sawhorses. The presence of a few chairs suggests that a little rest had been allowed during the long day. (Courtesy of Kearney Historical Museum.)

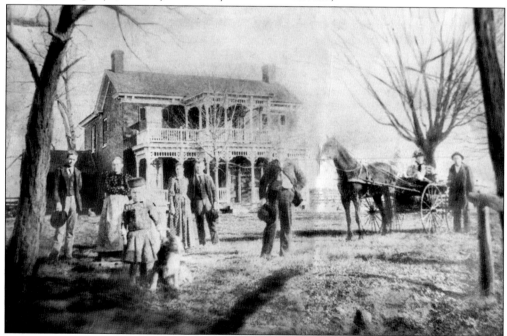

"The farmer and the cowman should be friends," opined Rodgers and Hammerstein in their musical *Oklahoma*. In Kearney, farmers and ranchers were always friends. The Shavers, pictured here at their home, were ranchers in the first generation, but successive generations included teachers, shopkeepers, ranchers, and, yes, farmers. (Courtesy of the Penrod Family.)

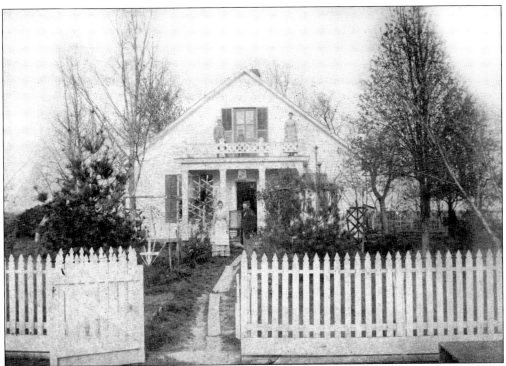

By the 1880s, Kearney residents enjoyed many of the trappings of civilized living. This house-proud family poses for a picture in 1881. Notice the boards that serve as a path from the street to the front door and the housekeeper, who has been relegated to a position somewhat apart from the children she watches over. (Courtesy of Kearney Historical Museum.)

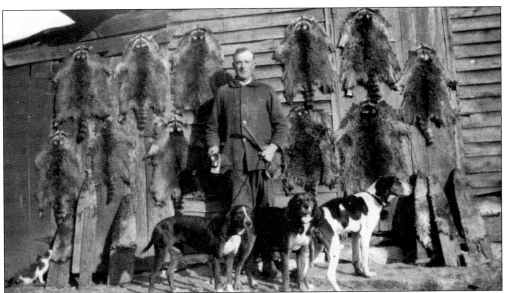

John McIlvain, posing here with his three faithful dogs, hunted and skinned animals for their fur. A full day as a rancher did not mean one's work was over. Kearney residents made their own clothes and coats and grew their own food. (Courtesy of Kearney Historical Museum.)

Some of the earliest homes built in Kearney were rough-hewn, but a little trim on the roof line went a long way towards making a family feel as though they had arrived. (Courtesy of Kearney Historical Museum.)

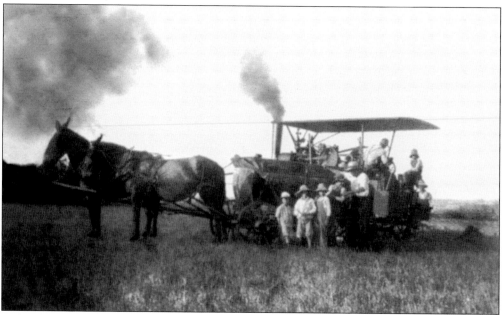

A family worked together on the farm, and nobody was allowed to shirk chores. Here a family takes a moment from its labors to pose for a picture with the much-valued steam plough. (Courtesy of Kearney Historical Museum.)

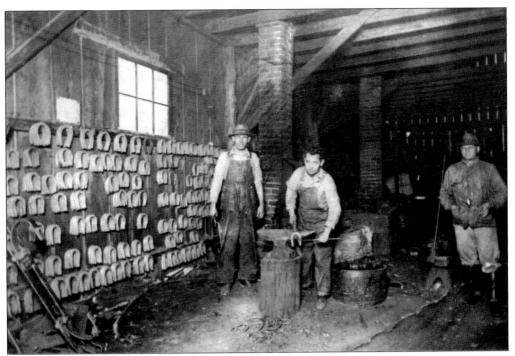

Kearney was initially powered by its horses—whether they were pulling the family carriage, a tractor, a thresher, or a wagon. Shoeing horses was an honorable, if difficult, trade. (Courtesy of Kearney Historical Museum.)

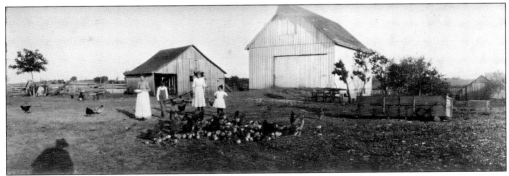

Pictured here in 1919, the Herman Hessel family raised poultry in addition to farming wheat, corn, barley, oats, and milo (sorghum). The farm has been recognized by the State of Missouri as a Centennial Farm, an honorific title given to working farms of at least 40 acres that have remained within the same family for over a century. (Courtesy of Elizabeth Ivy.)

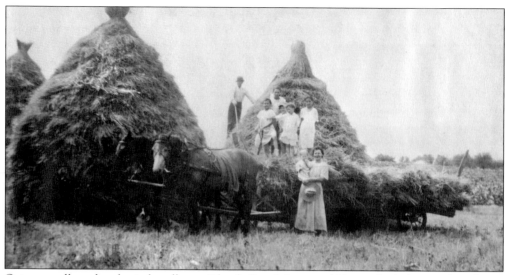

Oats were allowed to dry in bundles, or "shocks," and then would be stacked. A typical stack was about 20 to 25 feet in diameter at the bottom, tapering to a point at about 15 feet. The newly harvested oat stalks would be placed in a circle with grain heads turned in and the stems turned out so that the grain would stay dry. Successive layers would be smaller and smaller, creating a domed effect. (Courtesy of Elizabeth Ivy.)

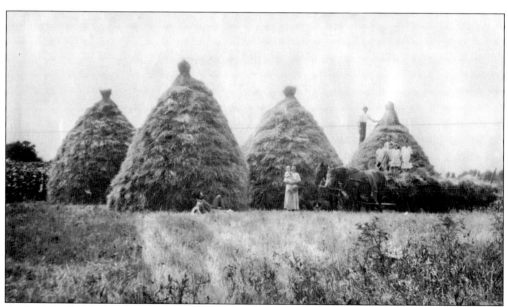

As the oats dried, the grain would drop to the ground and the stalks would remain as part of the stack's structure. Cattle would eat some of the stems, but the grain itself would be harvested for other uses. These stacks at the farm of Homer Hartel in 1913 were a source of food for the coming winter. (Courtesy of Elizabeth Ivy.)

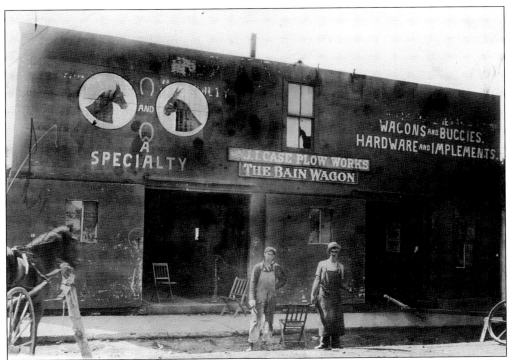

The J. I. Case Plough Works handled many customers, providing shoeing for horses as well as repair and sales of buggies, carriages, and farm machinery. The Bain Wagon Company of Kenosha, Wisconsin, was widely regarded as the manufacturer of the finest and sturdiest wagons for everyday use. (Courtesy of Kearney Historical Museum.)

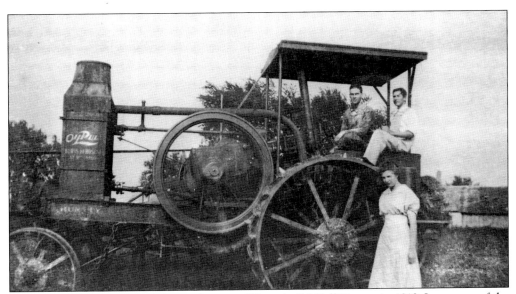

Benjamin Morris purchased the newly minted Rumely Oil Pull Tractor in 1918. It was one of the first oil tractors in the area, replacing the steam engine tractor. Morris's sons Benjamin and Ralph threshed hay on farms in the Mount Gilead neighborhood of Kearney. Pictured here are, from left to right, Ralph Morris, Claude Farner, and Grace Hessel. (Courtesy of Elizabeth Ivy.)

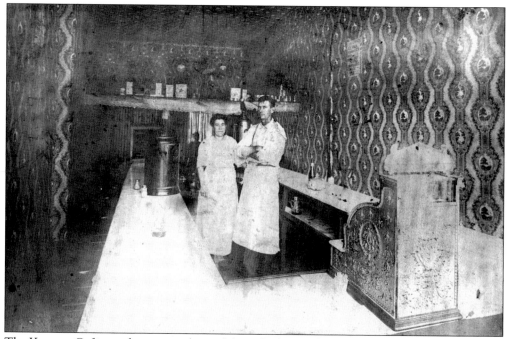

The Kearney Café was the center of town life in the late-19th and early-20th centuries. Pictured here are owners Mary Elma and John W. Gantry. They served friends, neighbors, and travelers. (Courtesy of Kearney Historical Museum.)

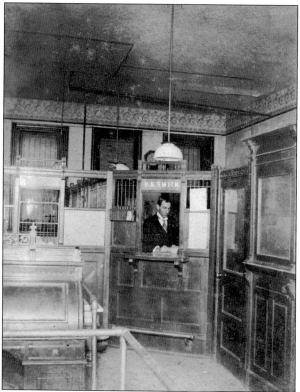

This photograph shows the interior of the original depot with its ticket booth during a brief slow period. Harry Smith sold Burlington Route One tickets to travelers. (Courtesy of Kearney Historical Museum.)

To accommodate the many travelers passing through the Kearney area, the Commercial Hotel was built. Today many franchise hotels and motels stand near I-35 just outside downtown. (Courtesy of Kearney Historical Museum.)

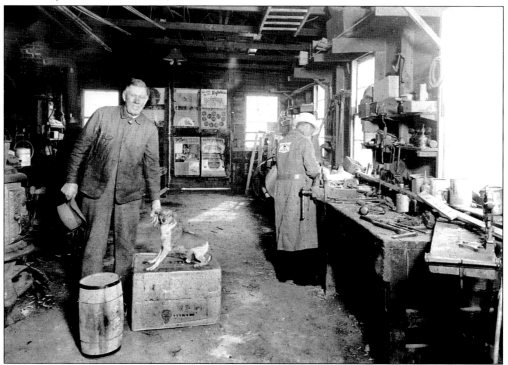

Nathan Carey owned a blacksmith shop that catered to the town's many equipment and horse needs. Here, standing at left, he is accompanied by his dog. His was a rough life, but he was a determined man. (Courtesy of Kearney Historical Museum.)

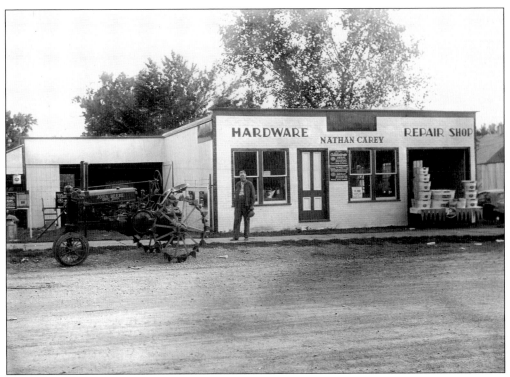

Keeping up with the times, Nathan Carey later sold and serviced John Deere machinery. Carey worked hard and understood the need for better and more efficient vehicles and machinery. (Courtesy of Kearney Historical Museum.)

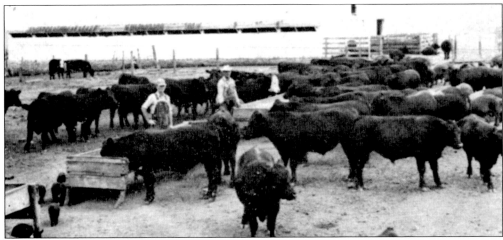

Standing here with Aberdeen Angus cattle are Wade Shanks (left) and Claude Moore, a longtime employee of the Shanks family. In the late 19th century, Kearney sold more cattle than any other town its size in the United States. (Courtesy of the Penrod Family.)

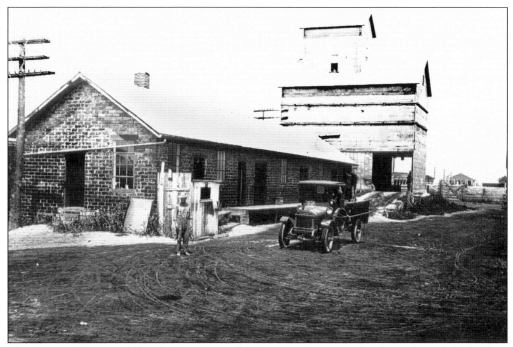

The Kearney Grain and Supply Cooperative had a grain elevator with a drive-through for loading and unloading grain. Getting grain to market was a farmer's most important task. (Courtesy of Kearney Historical Museum.)

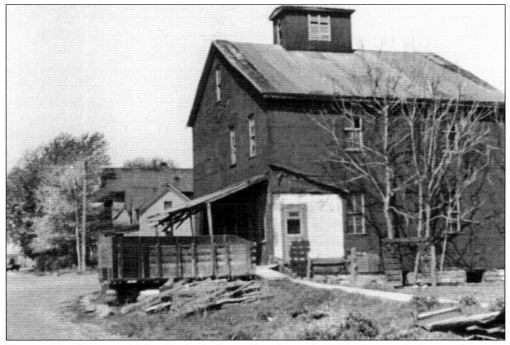

Thomas Henderson and John Eby built this mill in the early 1900s. It ground wheat and corn to make flour and meal. As many as four mills operated at any one time in Kearney. (Courtesy of Kearney Historical Museum.)

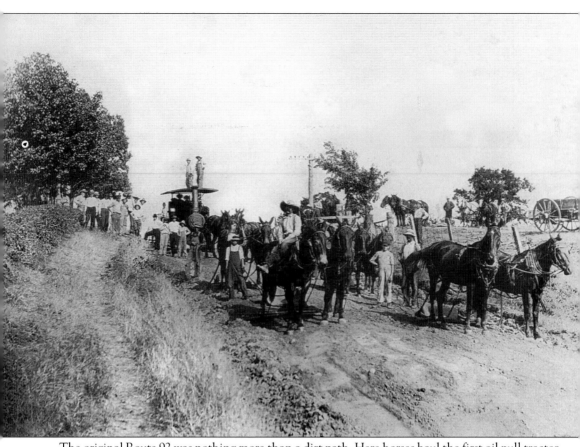

The original Route 92 was nothing more than a dirt path. Here horses haul the first oil pull tractor into town on what would a century later be a four-lane thoroughfare. In the 19th century, a trip outside of town was an extravagance. (Courtesy of Historical Museum.)

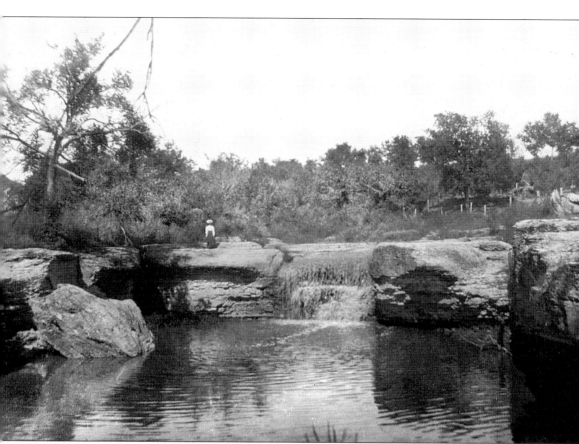

Just outside of Kearney was the Tryst Falls, which offered a cool respite from summer's heat. A family might make a vacation of visiting the falls. It is now a park that includes a playground, shelter houses, and picnic tables. (Courtesy of Kearney Historical Museum.)

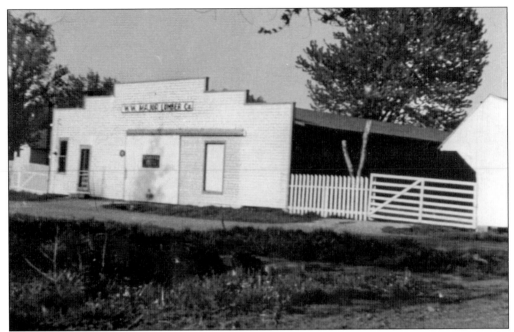

The Major family built a lumberyard to accommodate Kearney's explosive growth in the early 1900s. Kearney ranchers and farmers had worked hard, and their labors paid off. They were constructing bigger homes and expanding their network of barns and stables. (Courtesy of the Kearney Historical Museum.

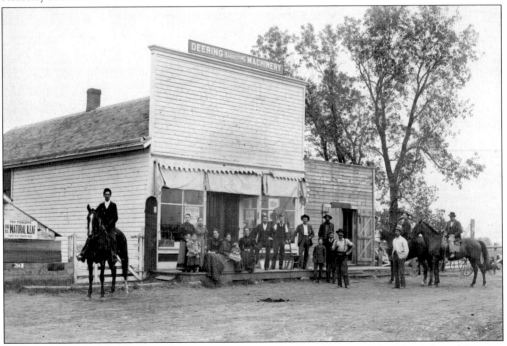

The Mathews family owned a machinery store that supplied local farmers. The Illinois-based Deering Manufacturing Company was the country's second-largest manufacturer of agricultural machinery such as tractors, threshers, and reapers. (Courtesy of the Kearney Historical Museum.)

In 1912, former president Theodore Roosevelt ran unsuccessfully for what would have been his third full term in office. He is pictured here at the back of a train making his case for his Bull Moose political party at the Kearney depot. (Courtesy of Elizabeth Ivy.)

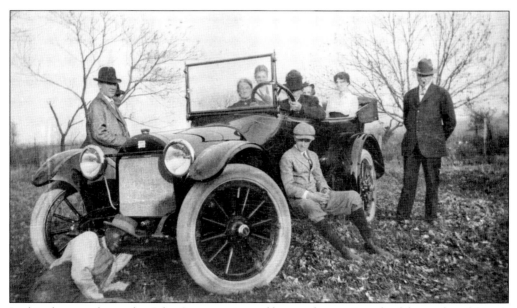

In this photograph, rancher John Stroeter, pictured here at the steering wheel, has gathered friends for an autumn afternoon ride in his 1916 Buick. Born in what was then called Prussia, Stroeter purchased a 214-acre farm in Kearney in 1882. He and his wife, Elizabeth, raised seven children there. (Courtesy of Elizabeth Ivy.)

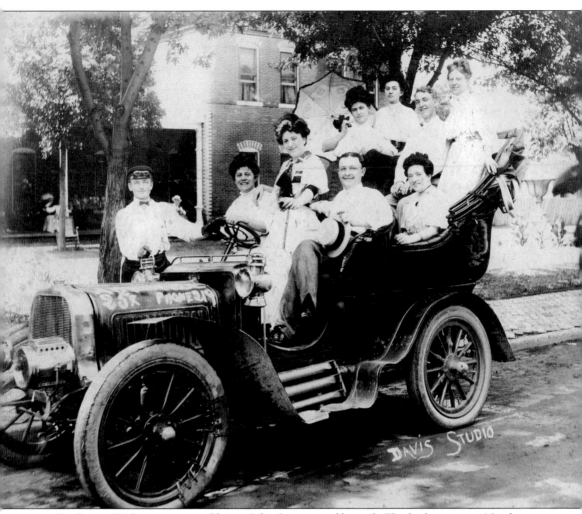

Dr. George W. Stroeter—son of farmer John Stroeter and his wife, Elizabeth—went to Northwestern University Dental School in Chicago. Upon his graduation, he was the first dentist in Kearney and was also the first to own a car, a very expensive Pope-Toledo. Stroeter gave rides in his car for 25¢ from the Maples Hotel in Excelsior Springs. He is pictured here in the front seat. (Courtesy of Elizabeth Ivy.)

When Doctor Stroeter's car rolled through Kearney, residents struggled to keep their frightened horses in line, and many would avoid using their buggies. Stroeter, pictured here behind the wheel, left Kearney in 1910 and enjoyed a successful practice in Kansas City. (Courtesy of Elizabeth Ivy.)

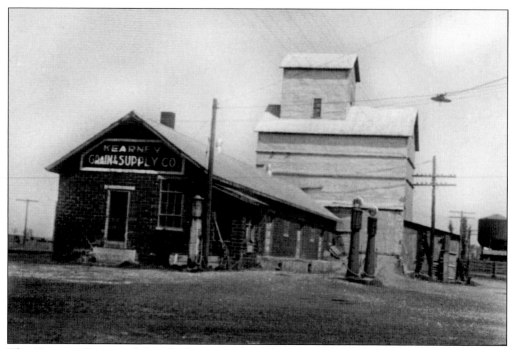

The Kearney Grain and Supply Cooperative promised its clients grain, feed, seed, fertilizer, and—with the advent of motorized farm vehicles—petroleum products. (Courtesy of Kearney Historical Museum.)

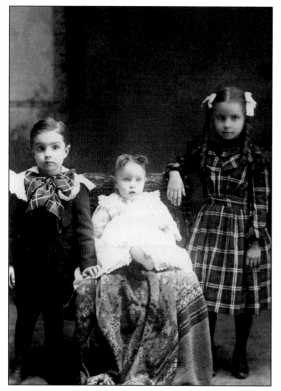

Prosperity for a ranch or farm family meant that its children could dress in finery for their portraits, but every Kearney mother knew how to stretch a dollar. Note how the boy's collar bow is made of the same fabric as his older sister's dress. (Courtesy of Kearney Historical Museum.)

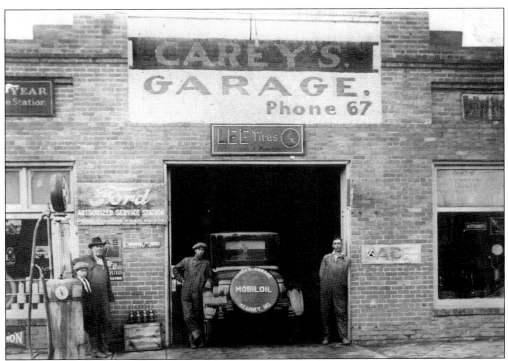

Nathan Carey (standing at left with son Stanley) saw his business grow with the need for automobile services. (Courtesy of Kearney Historical Museum.)

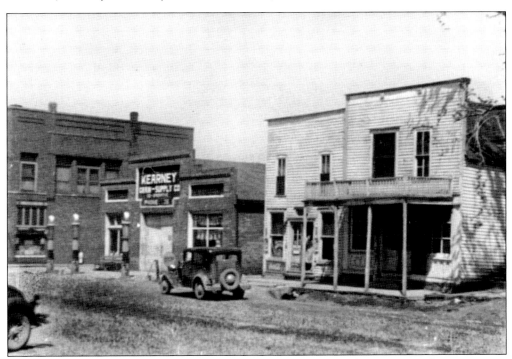

Muddy roads were the bane of any automobile owner, but a hot, dusty summer day meant easy driving. (Courtesy of Kearney Historical Museum.)

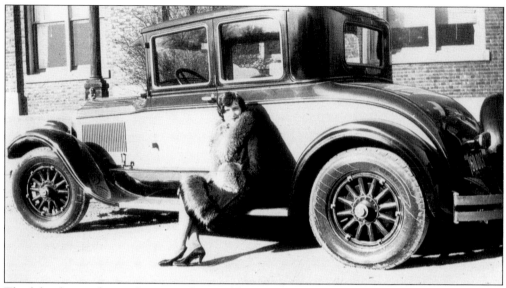

The life of a rancher or farmer with a sizable spread was not completely without luxuries. A nice car, a nice fur coat, and one might think of oneself as quite wealthy. (Courtesy of Kearney Historical Museum.)

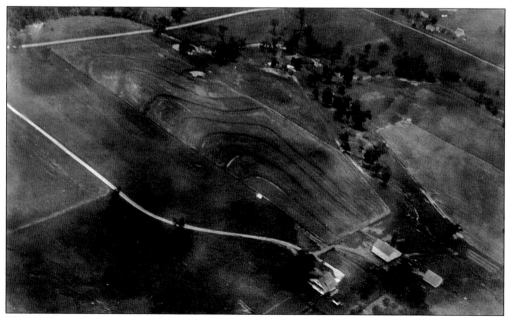

This 1949 aerial picture shows how much land the Wilkerson family maintained. Winn Wilkerson was also president of the Kearney Grain and Supply Company during the mid-1950s. (Courtesy of Penrod Family.)

Four

FAITH, EDUCATION, AND FRIENDSHIP

For a town to thrive, more than a strictly commercial interest must exist between its neighbors. A true community requires the bonding threads of faith, education, and friendship. In these, Kearney has long been, and continues to be, particularly blessed. It has many churches, but no church preaches intolerance against another. It has top-notch public schools, which replaced the town's original small private subscription schools. Kearney also abounds with clubs and organizations that promote fellowship and understanding amongst neighbors. All these things are particularly important to a town in which a person's nearest neighbor might live miles away.

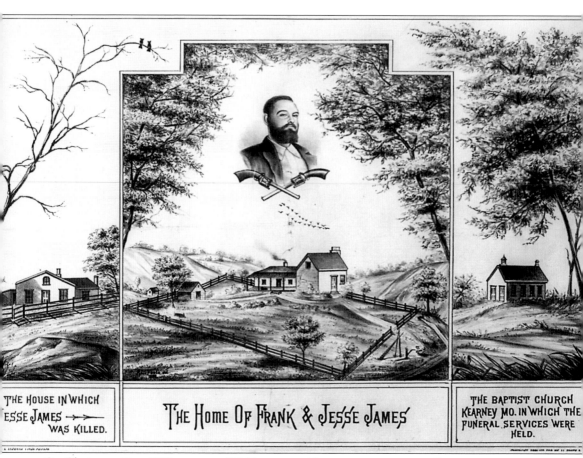

THE HOUSE IN WHICH JESSE JAMES →→→ WAS KILLED.

THE HOME OF FRANK & JESSE JAMES

THE BAPTIST CHURCH KEARNEY MO. IN WHICH THE FUNERAL SERVICES WERE HELD.

On Christmas Day, 1856, a group of 21 Kearney residents met to organize a Baptist congregation that they would name the Mount Olivet Church. Their covenant stated: "We pledge ourselves with God's help to walk together in brotherly love, to be present if it is possible at every church service, to rear our children in the fear and admonition of the Lord, to strive for a faithful gospel ministry at home and to aid in sending it to others." Its most famous parishioner was Jesse James, who sang in its choir. (Courtesy of State Historical Society of Missouri—Columbia.)

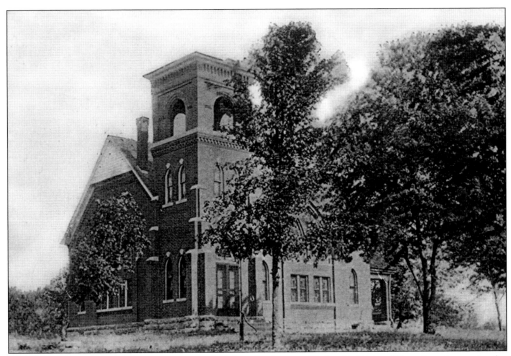

Mount Olivet Church's first service was held at the home of John S. Major. The church met in the Major family home and then in a schoolhouse until June 1857, when the congregation devised plans for a church building at what is now the Mount Olivet Cemetery. The church was completed in 1867 at a cost of $850.00, and its first pastor, J. E. Hughes, was hired in 1868. In 1872, the church's name was changed to The First Baptist Church. (Courtesy of Kearney Historical Museum.)

In June 1900, the original church was destroyed by a tornado. The congregation laid the cornerstone at its present location in 1901. In May 1903, the Rev. W. A. Crouch dedicated the sanctuary. This remarkable church is part of the Southern Baptist Conference. (Courtesy of the Kearney First Baptist Church.)

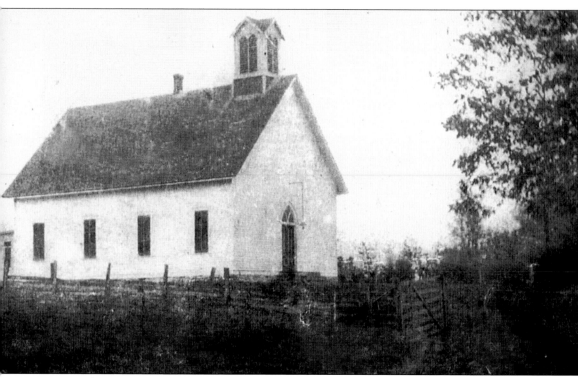

In 1866, homesteaders from around Kearney and Mount Olivet split from the Mount Olivet Christian Church. They called themselves the Christian Church of Kearney and established a congregation that met for the first time under a grove of trees on Prospect Street. Services were held in different places until 1868, when the Estes family donated land for a church building. Congregant Jack Pence hauled the lumber from St. Joseph with teams and wagons. Carpenters from the congregation volunteered their services. (Courtesy of Kearney Christian Church.)

Kearney always has room for a new congregation. The First Pentecostal Church has made its home in the original Christian Church. The pulpit, made from a cherry bed-stand, was donated in 1906 and moved when the Christian Church relocated to its new home in 1958.

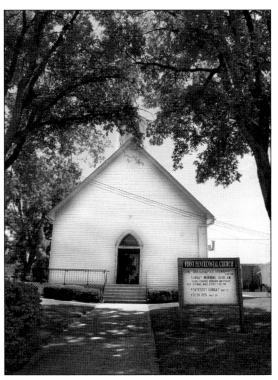

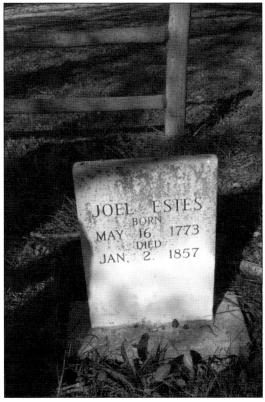

Members of the Estes family are buried behind the original Christian Church, now home to the First Pentecostal Church. Joel Estes once owned the land John Lawrence platted for the city of Kearney.

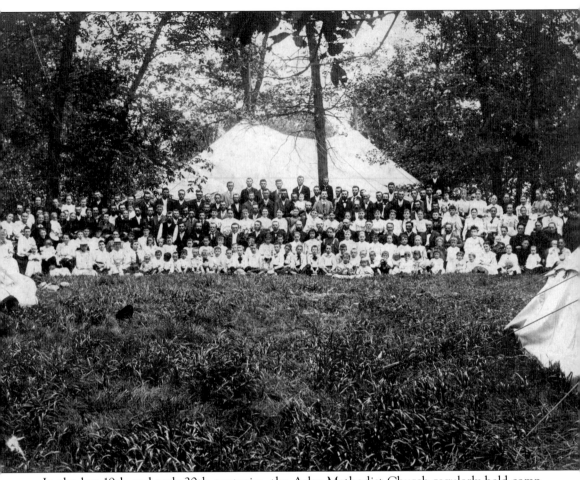

In the late-19th and early-20th centuries, the Arley Methodist Church regularly held camp meetings in the third week of August under the direction of Rev. William B. Woestemeyer. The meetings ran from morning til night over the course of the week in a grove of oak trees south of the Hartel farm. A tent was erected, seats were laid, and platforms were built for the altar and organ. (Courtesy of Elizabeth Ivy.)

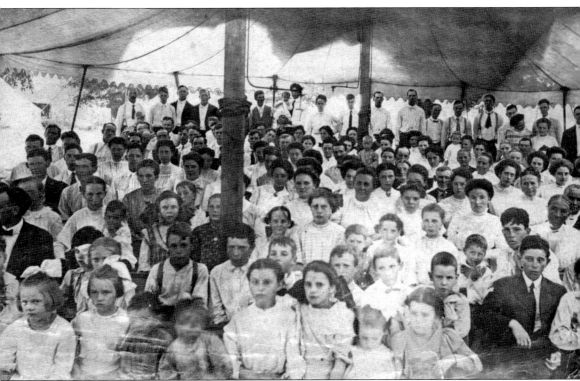

The Arley meetings were well attended because they came at the end of a grueling season of farm and ranch work. The camp was a welcome vacation. At the north end of the grove, a kitchen was built and two long tables laid out on which to serve meals. Some families came from so far away that they would erect tents in which to sleep overnight. Someone from each family would return to the family farm in the evenings to do chores. Today the Arley United Methodist Church has a small but very devoted congregation. (Courtesy of Elizabeth Ivy.)

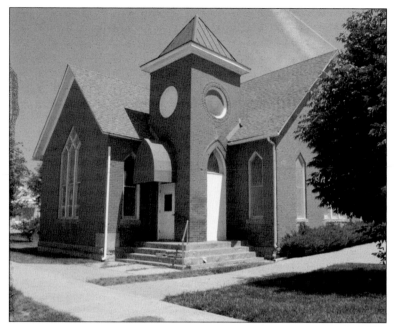

A second Methodist congregation met in downtown Kearney. Its original building was eventually converted to a childcare center in the Old Church Plaza shopping center. Today the First United Methodist Church of Kearney thrives at its new location on Route 92. (Courtesy of Edwin Seymour.)

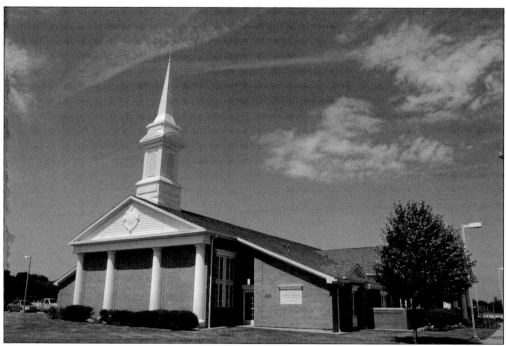

Fleeing persecution in New York state, Joseph Smith led the Church of Latter-Day Saints, commonly referred to the Mormon church, to settle in Jackson County in 1832. The group constantly collided with their "gentile" neighbors and were finally driven from their homes. They found refuge in Clay County, including in what would become the town of Kearney. The term "Jack Mormon" was used derisively to refer to county residents who offered Mormons shelter and comfort. Today the LDS of Kearney enjoy a peaceful relationship with members of all faiths. (Courtesy of Edwin Seymour.)

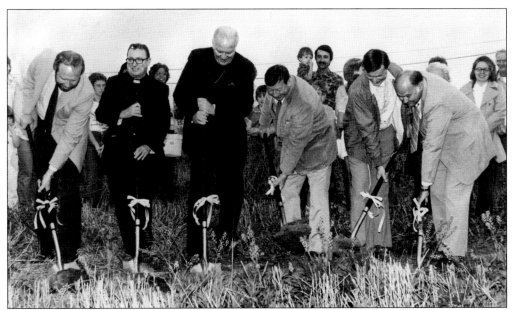

The Church of the Annunciation began as the Kearney-Holt Catholic Community in August 1980. The first Mass was held in the basement of the Kearney Trust Company and was later moved to the Kearney Middle School gym with a priest from Liberty offering Mass on a weekly basis. In 1981, the community moved to Trinity Lutheran Church for weekend liturgies, and Fr. Kenneth Criqui was appointed the church's first pastor. In January 1983, the congregation purchased the 10-acre tract of land where the church is now located. On July 1, 1994, the Church of the Annunciation was formally established as a parish. This photograph shows the ground-breaking ceremony for the happy congregation. (Courtesy of the Church of the Annunciation.)

In June 2006, the parish acquired the Knights of Columbus hall, which was renamed the Annunciation Community Center. The community center not only provides additional space for the parish's many activities but is also rented to the public for banquets, receptions, and a variety of other events. The parish continues to grow, serving as church home to over 540 registered families in 2009. (Courtesy of the Church of the Annunciation.)

Christ's Fellowship Church began in May 1981 as an independent church with services designed to reflect the ancient worship style found in the Psalms of David. Congregants are encouraged to follow the leading of God's Holy Spirit and worship freely by clapping, shouting, singing, dancing, and lifting hands. This worship helps congregants to live by the power of the Spirit and serve God's purposes throughout the week. (Courtesy of Christ's Fellowship Church.)

Community Covenant Church was founded in 1982. The congregation purchased land for a church building at the intersection of Nineteenth and Jefferson Streets, and founding pastor Mick Murphy broke ground in September 1986. The first service in the new building was held on July 19, 1987. Pastor Bill Nylund came in July 1992 and led an expansion project in 1998 and 1999. Pastor Mike Coglan has led the church since 2001, during which time additional land has been purchased for future use. (Courtesy of Community Covenant Church.)

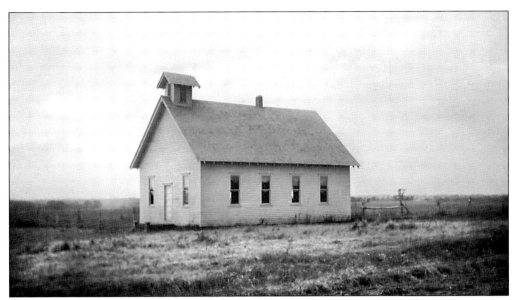

Kearney residents are deeply interested in their children's education. The Muddy Fork School in Kearney was named for the nearby Muddy Fork River. In 1954, Kearney consolidated its school district to include Estes, Summerset, Muddy Fork, Gilead, Sunnyside, and Kearney Schools. (Courtesy of Kearney Historical Museum)

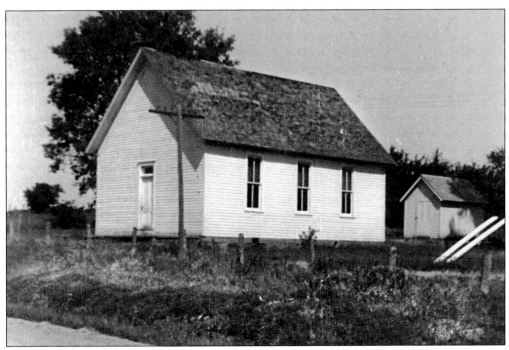

Summerset School was built in the same style as Muddy Fork School. The earliest schools were subscription schools, for which a family would pay tuition for the year either in cash or trade. In the early years, teachers were brought in from other areas and boarded to families, but within a generation, young women of Kearney would gain enough educational prowess to fill the town's teaching positions. (Courtesy of the Kearney Historical Museum.)

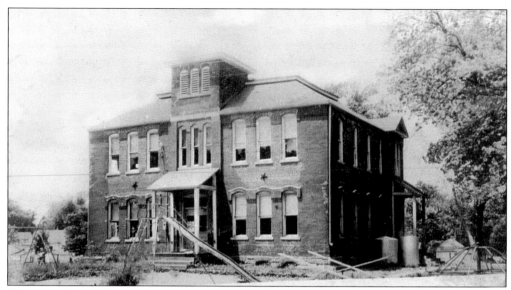

Here is an early-20th-century picture of the Kearney Elementary School. Built in 1898, it served as both an elementary and high school until 1922. At the beginning of the 21st century, Kearney could boast of four elementary schools, a middle school, and junior and senior high schools. (Courtesy of Kearney Historical Museum.)

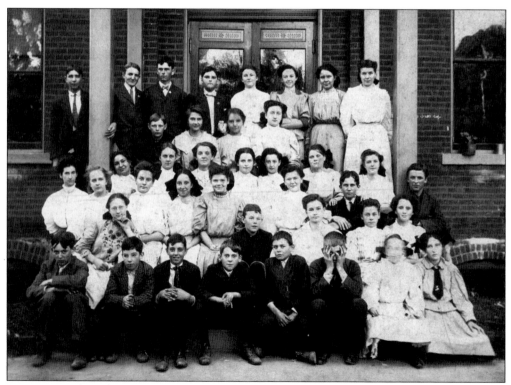

It is an eternal truth that some children just cannot sit still. In this class picture at the Kearney School, date unknown, note the girl in the first row, second from right. The two boys next to her seem a bit wary of the experience. (Courtesy of Elizabeth Ivy.)

Everyone in Kearney knows the words to the Kearney High School fight song: "Oh, play the game for Kearney, play hard and fair. Our boys will show them how to win a fair and square victory. Oh, play the game for Kearney! Never say to die. Fight, fight unto the end for Kearney High!" Kearney has been home to the Bulldogs since the opening of its first public school.

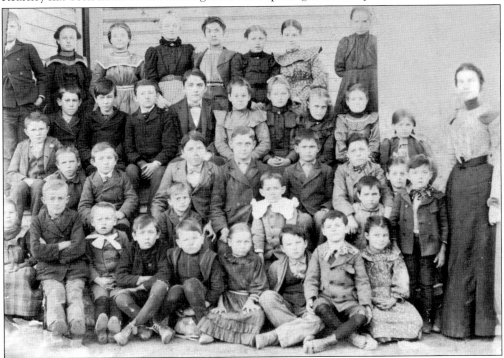

Kearney High School's 1913 graduating class poses at the Opera House. These early Bulldogs chose as their motto, "Ad Astra Per Astra," Latin for "through difficulty to the stars." In a few short years, many would be fighting in World War I. (Courtesy of Kearney Historical Museum.)

Emma Stroeter Freeman, pictured here in 1904, taught at the Arley School in Kearney. Arley was a largely German community at the northern edge of town. Emma was the youngest of Prussian-born farmer John Stroeter's seven children with his wife, Elizabeth, whose own parents had emigrated from Hesse-Darmstadt. (Courtesy of Elizabeth Ivy.)

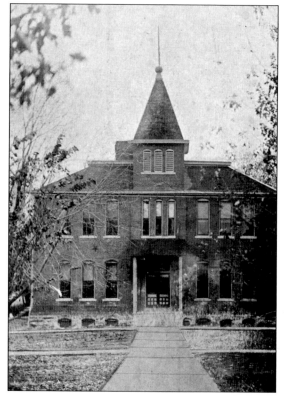

The Kearney School is featured in this 1908 postcard. The school had eight rooms and was heated by a coal furnace and later by oil. When a new elementary school was built on Highway 33, this older structure was abandoned. In February 1963, the Green Wrecking Company razed the building. (Courtesy of Elizabeth Ivy.)

Kearney High School

Report of _Earl Arnold_

for the year 19_10_ and 19_11_. _10th_ Grade.

Studies.	1st Quar.	2nd Quar.	3rd Quar.	4th Quar.	Final Ex.	Av'ge Grade
Algebra 2nd yr..	81	80	80	81	..	80²
Plane Geometry.						
Solid Geometry..						
Med.& Mod. Hist.						
English History..	84	85	88	90	90	87
English Lit.....	83	85	90	91		85¼
Latin Gram.....						
Caesar	92	96	92	90		92
Cicero.......						
Chemistry...... Spelling	60	87¼	95¼	92⅝	.	84
Times Tardy ..	0	0	0	0		
Days Absent....	1	0	¼	0		
Days Present....	39	40	37¾	40		

Scale of Grading :

96 to 100 is excellent; 85 to 96 is good; 70 to 85 is poor; below 70 means failed.

Mrs. Lutie Walsdorf Teacher.

High school sophomore Earl Arnold came home with pretty good grades at the end of the 1910–1911 school year. He did very well at Caesar in Latin Grammar. His Algebra, though, could have used some of work. (Courtesy of Kearney Historical Museum.)

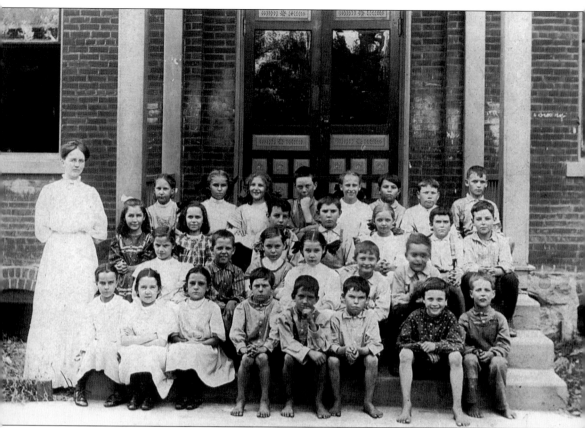

It is unclear the exact year that Kearney School was organized, but the earliest record is of 1888, when W. J. Yates, R. W. Groomer, and S. A. Pence were directors. The very first graduating class in 1891 consisted of just two students—Visa Sims and Web Bevens. In this photograph, notice how the boys in the front row are barefoot. (Courtesy of Elizabeth Ivy.)

The Kearney High School 1922–1923 basketball team stands for a picture with coach Troy Smith. From left to right are (first row) Louis Riley, Clarence Gentry, and Roy Easton; (second row) Claude Thompson and Smith; (third row) A. B. Evans, Earl Gentry, and David Henderson. (Courtesy of Kearney Historical Museum.)

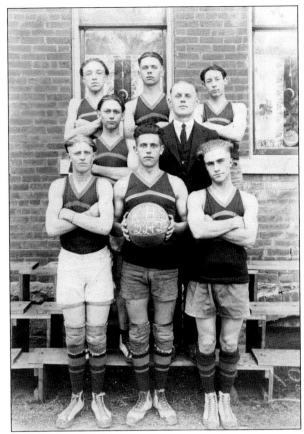

The Kearney High School did not have an indoor auditorium until 1939 when mayor H. Roe Bartle dedicated the addition. Kearney High School boasted the first indoor auditorium in the district. (Courtesy of Kearney Historical Museum.)

For many years, Kearney High School had just two sports teams—a girls basketball team and a boys basketball team. Residents of neighboring towns complained that Kearney players were so good because they did not do anything else. In 1961, Kearney's boys team won the State Championship in the S division for the first time. (Courtesy of Kearney Historical Museum.)

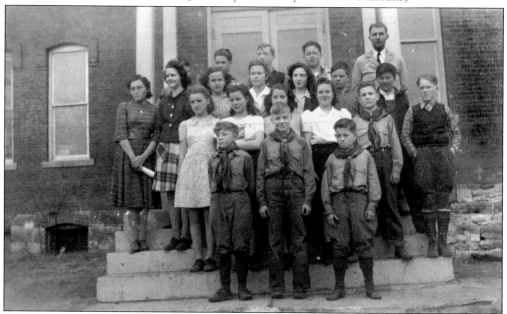

In 1943, Kearney seventh and eighth graders pose for a class picture. Their parents had struggled through the Great Depression and had seen their older children go off to war, but better days were coming. (Courtesy of Elizabeth Ivy.)

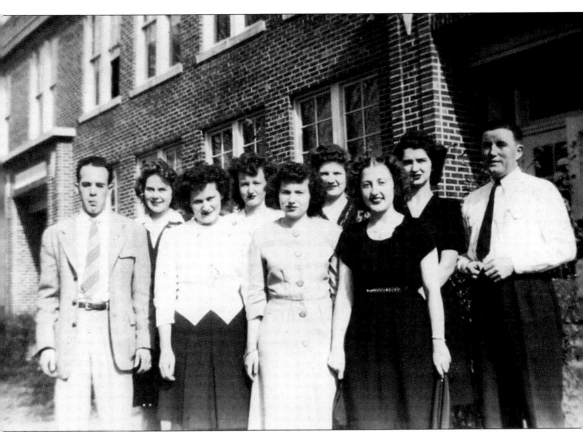

This photograph shows the 1946 graduating class of Kearney High School—notably depleted of male students. Many of the young men of the area volunteered for military service at the earliest opportunity, sometimes even gaining an early graduation so that they might leave. The early enlistments no doubt broke a few hearts in addition to skewing the male-female ratio of the class. (Courtesy of Kearney Historical Museum.)

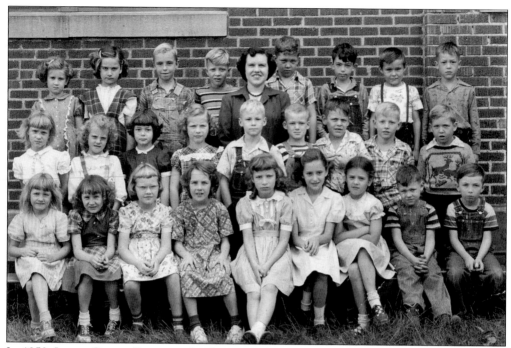

In 1950, Joann Groom Pence taught this second grade class at Kearney Elementary School. The Groom and Pence families were some of Kearney's first settlers. (Courtesy of Kearney Historical Museum.)

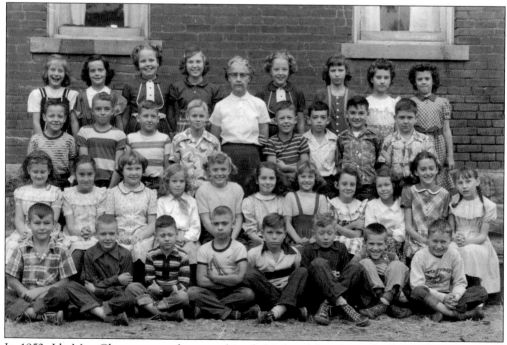

In 1952, Ida Mae Clevenger taught a combined third and fourth grade class. Clevenger never married, devoting herself entirely to her work. She and her brother lived in nearby Liberty. (Courtesy of Kearney Historical Museum.)

Some of Kearney's children go on to college and careers in far-off places, but many find their hometown to be a wonderful place to live and to raise a family. Shown here in high school, future Kearney fire chief Larry Pratt probably already knew that Kearney would always be his home. (Courtesy of Kearney Fire Department.)

Below, the Odd Fellows Hall, home to the Kearney 247 chapter of the Independent Order of Odd Fellows, stands at the center of downtown Kearney. IOOF members receive many benefits, but the national society is best-noted for its mission, "To Improve and Elevate the Character of Mankind." (Courtesy of Kearney Historical Museum.)

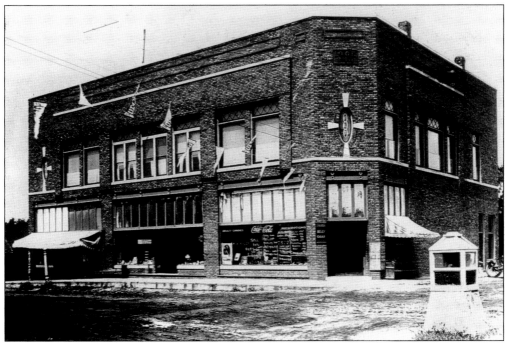

Much like the Masons, the Odd Fellows have an elaborate set of rituals and hierarchy. Odd Fellows initiates face four levels of Subordinate Lodge membership before being elevated to the Encampment and from there, to the Patriarchs Militant. Regardless of the pomp, Kearney Odd Fellows enjoyed some prosaic membership perks: for many years, a comb and brush hung in the hall's front hallway so that members might groom themselves. (Courtesy of Kearney Historical Museum.)

AN
Old Fashioned Mother
A Dramatic Parable of a Mother's Love
In Three Acts
By Walter Ben Hare

Deborah Underhill, a mother in Israel	Orby Shipp
Widder Bill Pindle, leader of choir	Bernice Mathews
Lowizy Custard, plain sewing and gossip	Ellen Baldwin
Isabel Simpscott, village belle	Irene Dykes
Gloriana Perkins, as good as gold	Nelle Hall
Sukey Pindle, the widder's mite	Roma Waers
John Underhill, prodigal son	Jack Ruddle
Charlie Underhill, the elder brother	Bluford Moberly
Brother Jonah Quackenbush, a whited sepulcher	Roger Morrow
Jerry Gosling, a merry heart	Kirk Kennedy
Enoch Rone, outcast, wanderer	Russell Logan
Quintus Todd, county sheriff	Claud Farner

The village choir. Time: Twenty years ago. Place: The village of Canton, N. Y. Time of playing: Two hours and fifteen minutes

ACT I—Settin' room at Underhill farm house. An afternoon in late March Good Samaritan

ACT II—Same scene three years later. A winter's afternoon. A mother's love. Tobe Rulo on death-bed, saying he was guilty, not John

ACT III—Two years later. A morning in autumn. The prodigal son.

Friday, March 22
Odd Fellows' Hall
Admission: 25c
Proceeds for the benefit of the Red Cross

Music { Eleanor Major / Ruth Erwin / Halcoline Stroeter Directors { John T. Hall / Mrs. G. L. Humphrey

The Odd Fellows Hall hosted many benefits and fund-raisers., including this 1918 production of *An Old Fashioned Mother*, a popular Walter Ben Hare play that emphasized a mother's devotion to her prodigal son. Since 1992, Kearney thespians have joined with those from nearby Holt to form the Kearney-Holt Community Theater. Performances are held both at the high school and at the Kearney Auditorium. (Courtesy of Kearney Historical Museum.)

When Kearney's Odd Fellows chapter disbanded in 2000, the building and its contents were sold. Jim Leuschke asked for and was given two coffins used in Odd Fellows rituals for use as props in a community theater production. At his home, one of the coffin lids came loose and he discovered a set of bones, later established by the Jackson County Medical Examiner to be human remains, most likely embalmed in the 1800s. Many Odd Fellows lodges around the country use a human skeleton in their initiation rituals as a reminder of mortality.

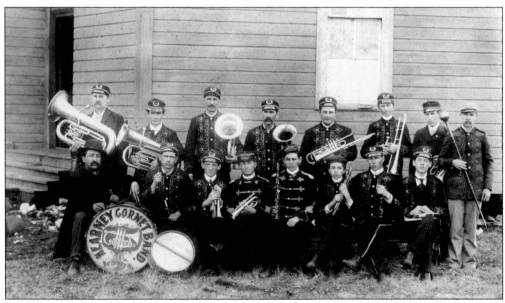

The Kearney cornet band practiced in the Tabernacle building, meeting place of the local Women's Temperance Union chapter. From left to right are (first row) George Chrisman, George Gentry, Vest Rice, band leader Joel Estes, Urbie Harper, Sam Pence, Bob Hall, and music director Luke Williams; (second row) Smith Crawford, John Foreman, Will Courtney, Mike Cave, Slim Milburn, Willie Stroeter, Arch Hall, and Hilly Henderson. (Courtesy of Kearney Historical Museum.)

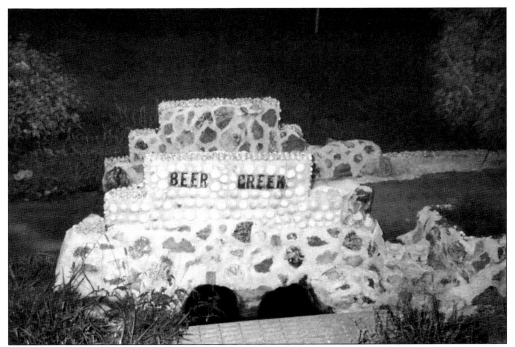

The Beer Creek neighborhood is named for the alcoholic river created by the Women's Christian Temperance Union when it poured all the liquor from the town's only bar into the streets. A playful resident decorated his parkway to honor the flow of liquor. (Courtesy of Larry Pratt.)

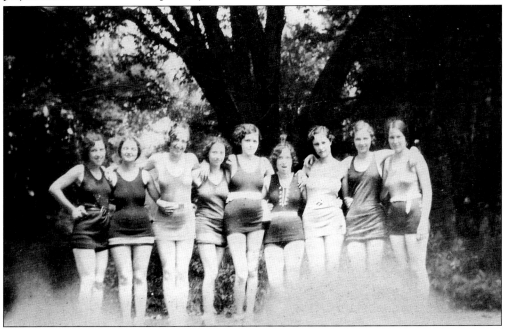

Many Kearney residents went to nearby Excelsior Springs to enjoy the cool water on a hot summer day. In this picture, these Kearney beauties interrupt their frolicking to pose for the camera. The more than 20 mineral springs oozing from the Fishing River made the town a popular destination; drinking the waters was said to cure many ailments. (Courtesy of Elizabeth Ivy.)

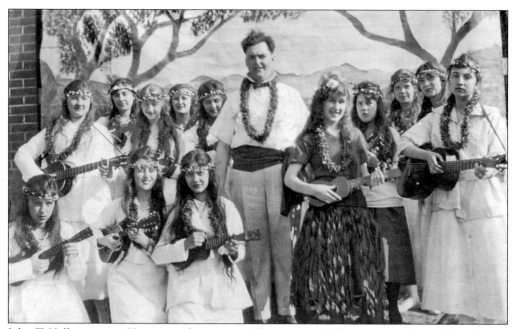

John T. Hall grew up in Kearney and went on to Chicago to make his name in theater. He achieved success as a singer, dancer, actor, and director but returned to Kearney in the summertime to direct plays and musicals. In this 1919 photograph, he poses with Kearney's Hawaiian Banjo Orchestra. (Courtesy of the Penrod family.)

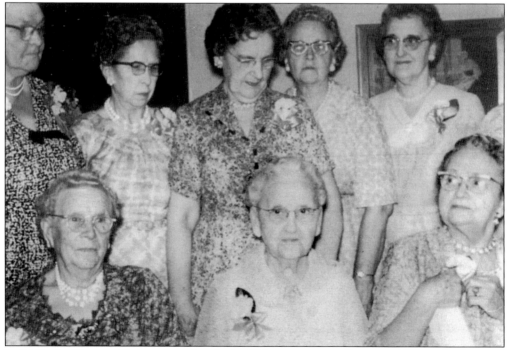

In 1962, the Keepers Club got together for its 35th anniversary. Begun in 1927 at the home of Florence Shanks, the club encouraged friendships between Kearney women. Its motto was, "In Helping Others, We Help Ourselves." (Courtesy of Elizabeth Ivy.)

Five

SERVICE AND SACRIFICE

Kearney continued to grow through the 20th century, but this growth did not come without hardship and sacrifice. During the Great Depression, many families saw their land repossessed or their neighbors cast into the street. Sons were sent to fight in wars in places that were just a dot on the map—Normandy, Choisin Reservoir, Saigon, and Tikrit. The vagaries of international trade would send the price of grain and cattle skyrocketing or plummeting, and it took a courageous banker to guide his clients through these fluctuations.

Kearney's farmers and ranchers, who had already benefitted from the presence of the railroad, profited again upon the arrival of the highways that connected them even more closely with the surrounding world. In doing so, however, the highways also brought changes in Kearney's fundamental nature. The franchise restaurants, hotels, and gas stations meant to appeal to the traveler bankrupted many locally owned businesses. Kearney's proximity to Kansas City transformed the town from a rural agricultural community into a suburb with sprawling subdivisions and a ballooning school population. Consequently, the celebration of the town's 100th anniversary was both a moment of proud reflection upon the past and concern over what the future might hold.

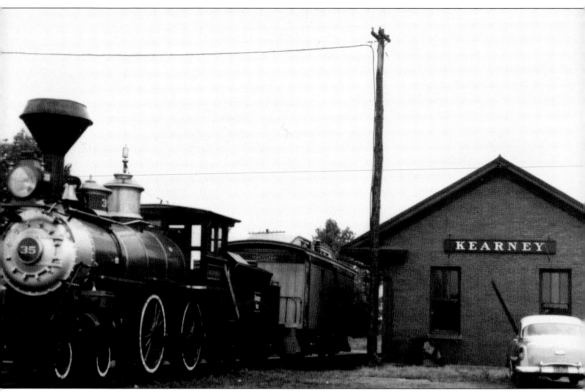

Kearney traditionally relied heavily on the railroad to transport its cattle and grain to market. However, the emergence of automobiles and trucks as a cheaper form of transportation required that Kearney be well positioned with respect to the highway system. A local government determined to bring Kearney to the attention of highway planners protected the town's future. Kearney is snugly fit at the intersection of Route 92 and Interstate 35. (Courtesy of Kearney Historical Museum.)

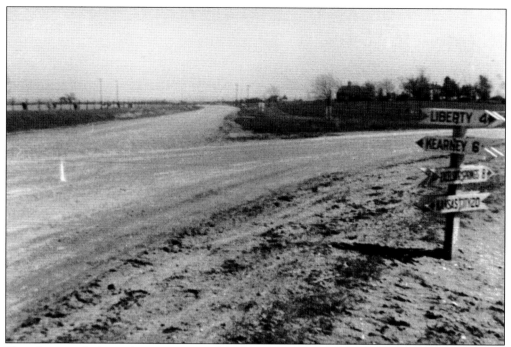

This photograph shows the intersection of Highway 33 and Highway 69 in the early 1900s. Liberty, Excelsior Springs, and Kansas City were all within reach but were still separated from Kearney by miles of farms and ranches. Today with every exit on Interstate 35 populated with fast food restaurants and chain gas stations, it is hard to remember a time of such isolation. (Courtesy of Kearney Historical Museum.)

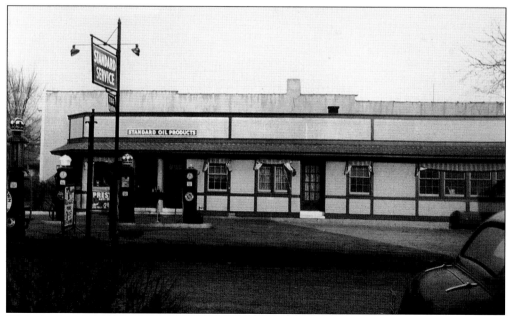

With the building of Interstate 35 northeast of town, Kearney residents drifted away from such family-owned businesses as this gas station. (Courtesy of Kearney Historical Museum.)

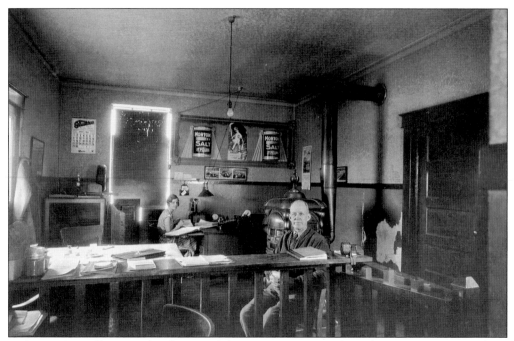

Parker McConnell managed and operated the Kearney Grain and Supply Cooperative throughout the 1940s. He was a patient and hardworking man who guided the cooperative through hard times. (Courtesy of Kearney Historical Museum.)

In World War II, most every man and woman who could serve the country did so. This photograph shows the Careys as they prepare to ship out in 1943. Father David (right) served in the Army, and son Ray served in the Navy. (Courtesy of Larry Pratt.)

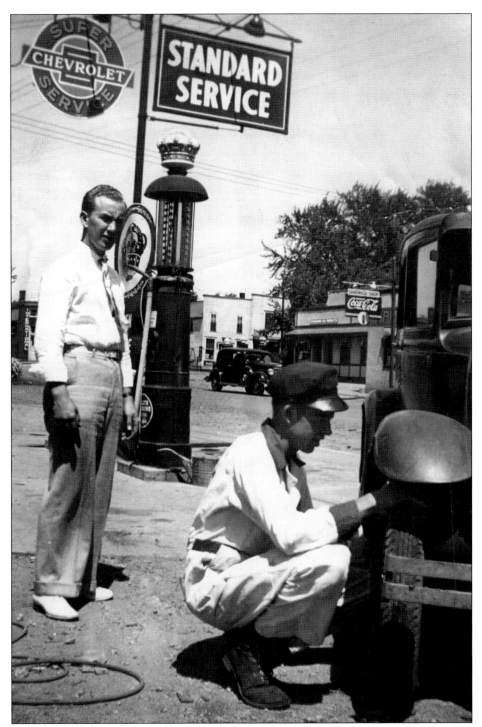

John Ervin's brother, Stanley "Perky" Ervin, had a lifelong interest in motor vehicles. Here he checks the tires on Alderman Kenneth Dagley's car in 1940. In 1949, he was instrumental in the purchase and repair of the first village fire truck and later served as president of the school board. (Courtesy of Larry Pratt.)

The Kearney Grain and Supply Cooperative's directors pose for a picture in the mid-1940s. Parker McConnell (far right) managed the cooperative for many years. (Courtesy of Kearney Historical Museum.)

After World War II, Ray Carey returned from service in the Navy. He managed the Kearney Grain and Supply Cooperative in 1950. In this photograph, he leaves work on his motorcycle. (Courtesy of Kearney Historical Museum.)

George T. Gentry and his wife, Lee, pose for a picture in 1943. Like many residents of Kearney, George wore many hats: he served as both town mayor and head of a trucking business. (Courtesy of Kearney Historical Museum.)

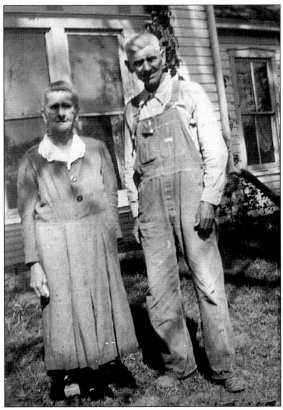

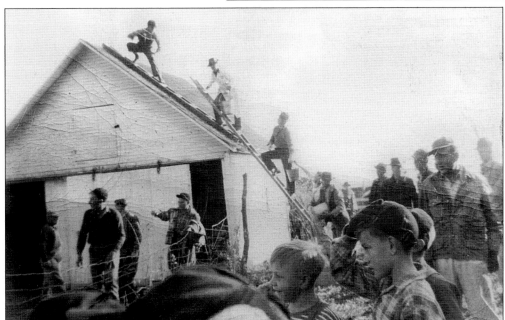

In 1948, a devastating fire gutted this home on Christian Ridge (now Prospect Avenue), despite the best efforts of the volunteer force. The town responded by forming a professional fire department, calling upon U. A. "Red" Pratt to be its first chief. (Courtesy of Kearney Fire Department.)

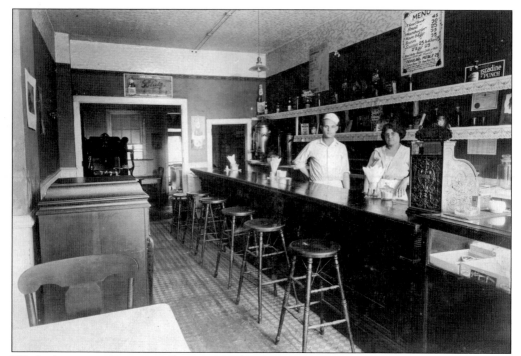

While downtown Kearney still maintains family-owned restaurants, the restaurants near the intersection of Interstate 35 and Route 92 are nationally recognized chains and franchises. The Kearney Café is no more. (Courtesy of Kearney Historical Museum.)

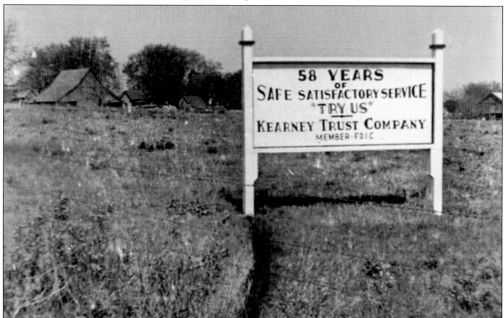

Formed in 1882, the Kearney Bank did well in its first year, paying a 25-percent dividend to its shareholders, which included members of the James family. The bank was originally set up to serve a rural farming and ranching community but now serves businesses, commuters, and farmers alike. In 1920, it changed its name to Kearney Trust Company. (Courtesy of Elizabeth Ivy.)

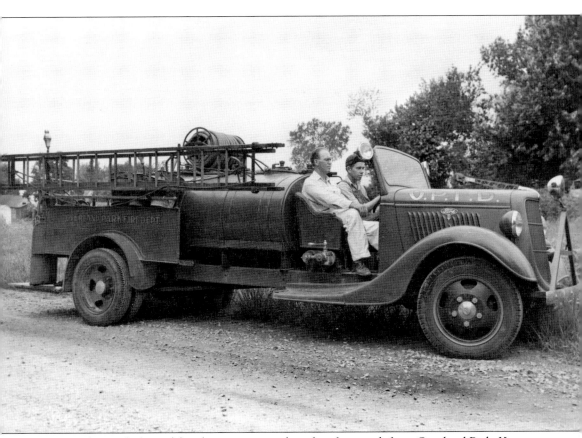

In 1949, the newly formed fire department purchased its first truck from Overland Park, Kansas. In this photograph, U. A. "Red" Pratt and Stanley "Perky" Ervin test drive the 1939 vehicle, which cost the village $1800. (Courtesy of Kearney Fire Department.)

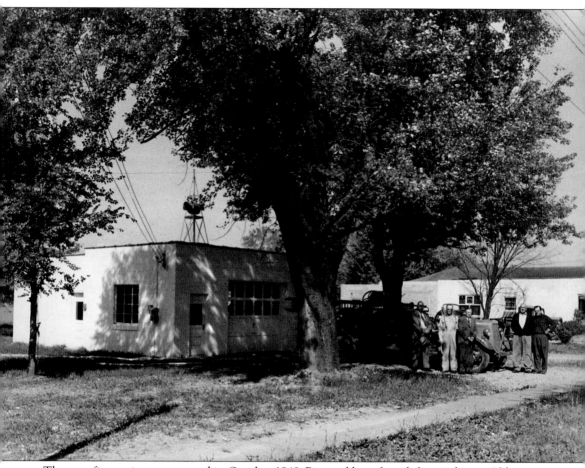

The new fire station was opened in October 1949. Pictured here from left to right are Alderman Toliver Cave, fire chief Red Pratt, Charles Smith, Mayor Arthur Bratton, and Alderman Kenneth Dagley. These men oversaw the building of the fire department and the purchase of its first fire truck. (Courtesy of Kearney Fire Department.)

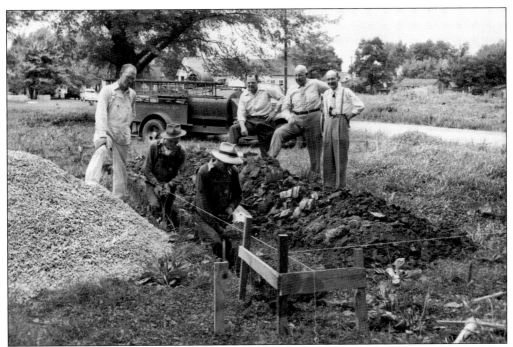

Fire chief Red Pratt, Alderman Kenneth Dagley, Mayor Arthur Bratton, and city clerk Cecil Turnage oversee the digging of the foundation of what would become Kearney's fire station.

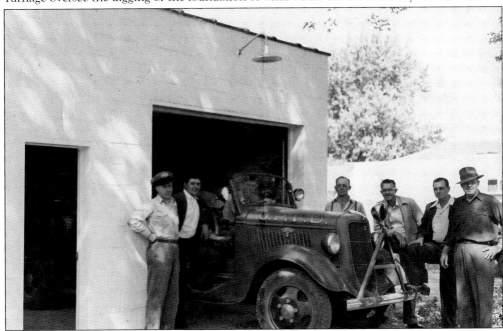

On October 13, 1949, some of Kearney's volunteer firefighters gather to admire their new purchase: the town's first fire truck. From left to right, they are Herbert Riley, Robert Whipple, Stanley "Perky" Ervin (in driver's seat), U. A. "Red" Pratt, Reynolds Klepper, Jimmy Hall, and Kenneth Dagley. Pratt would become the town's first paid fire chief. Residents were instructed: "Pick up the phone and say, 'I want to report a fire.'" (Photographs courtesy of Kearney Fire Department.)

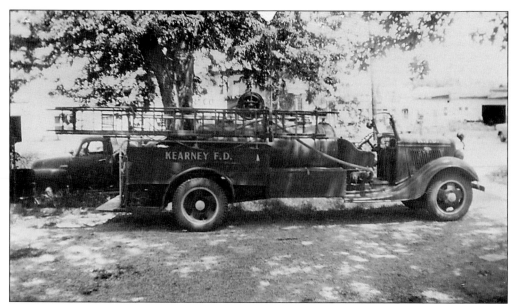

Stanley "Perky" Ervin had his work cut out for him in restoring the Overland Park fire engine for use by the Kearney Fire Department. One of the first orders of business was repainting the side with "Kearney F. D." (Courtesy of Kearney Fire Department.)

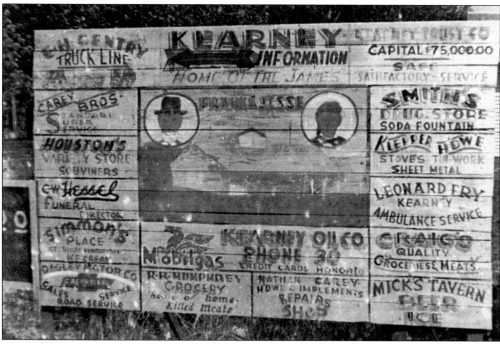

On Raymond Hall Road, an early billboard extols Kearney business, reminding people that the town was home to the James brothers. The town has struggled for years with whether or not to embrace the memory of Jesse and Frank and their outlaw cohorts. (Courtesy of Kearney Historical Museum.)

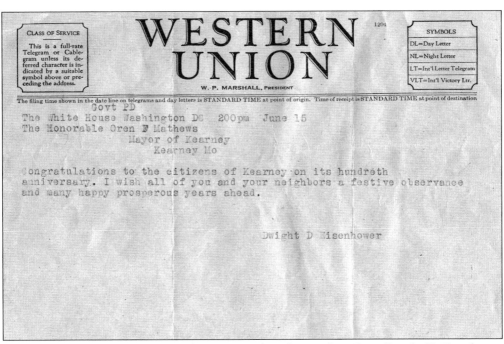

The filing time shown in the date line on telegrams and day letters is STANDARD TIME at point of origin. Time of receipt is STANDARD TIME at point of destination

Govt PD
The White House Washington DC 200pm June 15
The Honorable Oren F Mathews
 Mayor of Kearney
 Kearney Mo

Congratulations to the citizens of Kearney on its hundreth
anniversary. I wish all of you and your neighbors a festive observance
and many happy prosperous years ahead.

 Dwight D Eisenhower

On June 15, 1956, mayor Oren Mathews received a telegram from Pres. Dwight D. Eisenhower congratulating the town on its 100th anniversary. Sadly, the President was not able to accept the mayor's invitation to attend the parade and festivities. (Courtesy of Kearney Historical Museum.)

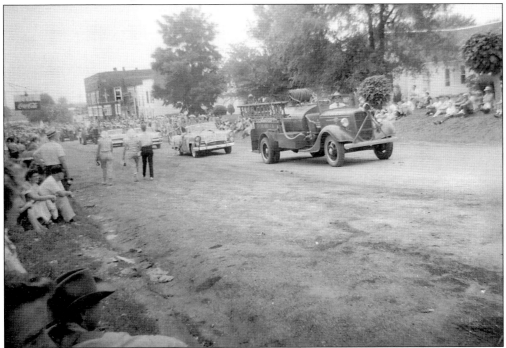

Although President Eisenhower missed Kearney's Centennial festivities in 1956, the residents had a happy time without him. The first fire truck was part of the parade down Washington Avenue. (Courtesy of Kearney Fire Department.)

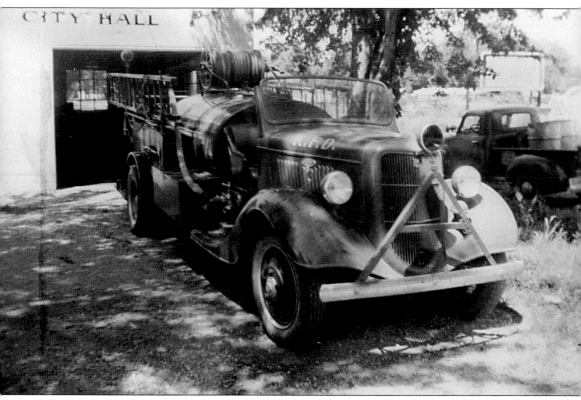

The town's first fire truck is photographed here sitting outside the first bay of the combined city hall, police, and fire departments. Today the building serves as the Kearney police station. (Courtesy of Kearney Fire Department.)

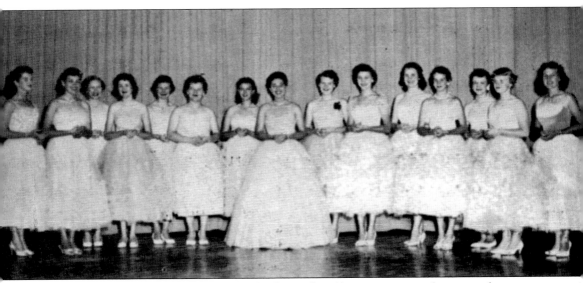

When Kearney celebrated its centennial, the first order of business was to select a parade queen. Fifteen Kearney beauties vied for the honor. From left to right are Charlotte Nelson, Lola Sanders, Beverly Ellington, Carol Musgrove, Annajane Denny, Norma Jeanne Moore, Gloria Duncan, Pat Klepper, Mary Prentice, Shirley Melton, Willa Armstrong, Linda Lanham, Judy Woolery, Beverly Barr, and Regina Ferril. Shirley Melton won out and served as the Centennial Queen. (Courtesy of the Penrod family.)

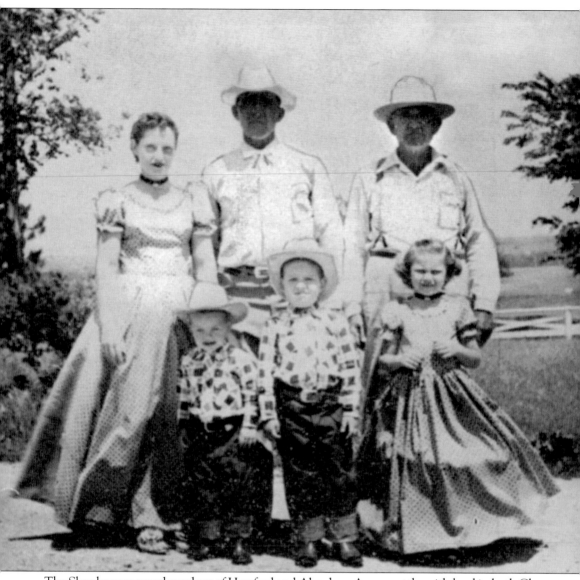

The Shanks were proud ranchers of Hereford and Aberdeen Angus cattle, with land in both Clay and Clinton Counties. Here the family poses in Western costume for the 1956 centennial celebration. Shown from left to right are (first row) Dennis Ray, Gary Wade, and Vicky Lynn; (second row) Bettie Ann Shanks, Wade Shanks, and Harry Shanks. (Courtesy of the Penrod family.)

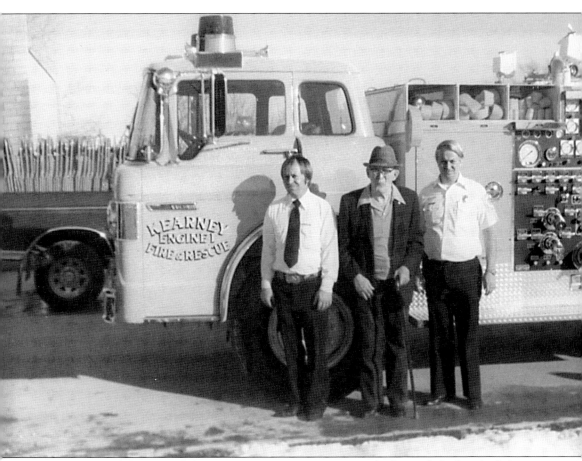

The Pratt family has served the community in many ways, not the least of which is firefighting. In this February 1982 picture, former fire chief Red Pratt stands between his two sons. Jim, to his right, served as fire chief in 1968, and Larry, to his left, began his tenure as chief in 2001. When Red died in 1990, his body was transported to the cemetery on top of a fire truck. (Courtesy of the Kearney Fire Department.)

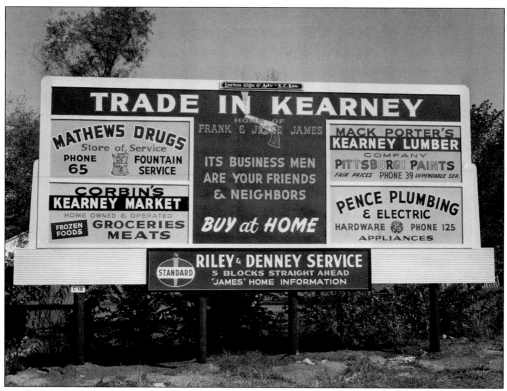

In 1959, this billboard encouraged Kearney citizens to patronize local businesses. Interstate Highway 35 put tremendous pressure on local businesses, dividing the town roughly in half. (Courtesy of the Kearney Historical Museum.)

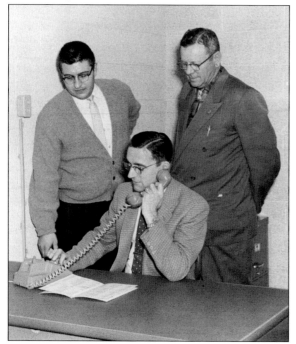

In 1960, Mayor Oren Mathews placed the first call on a rotary phone in Kearney. A dial telephone system had been put into effect, completing a $71,000 project by the United Telephone Company. Prior to 1960, a manually operated switchboard was in place. (Courtesy of the Penrod family.)

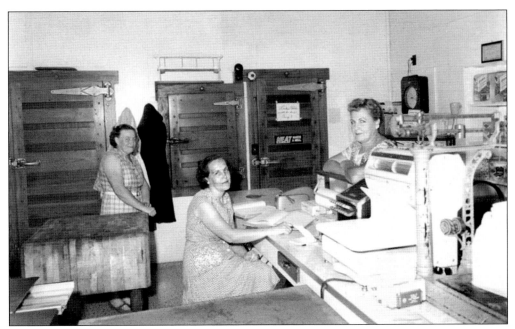

At Parson's Meat Locker in downtown Kearney in 1960, these women pose for a picture. From left to right, they are Louise Pratt, Emma Miller, and Laverna Watson. Chain grocery stores meant the end of the small butcher shop. (Courtesy of the Kearney Historical Museum.)

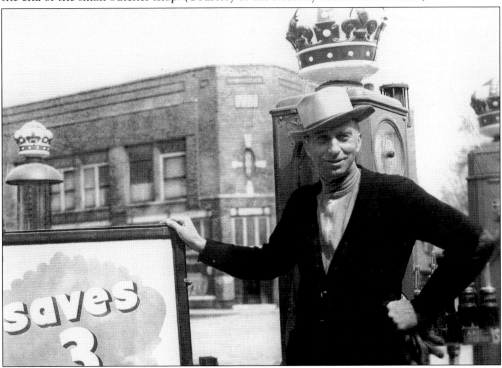

Ray Carey's Standard Oil Service Station was fit for a king—with a crown on every pump. Here Ray stands in front of the Red Crown pump just across the intersection from the Odd Fellow's building. (Courtesy of the Kearney Fire Department.)

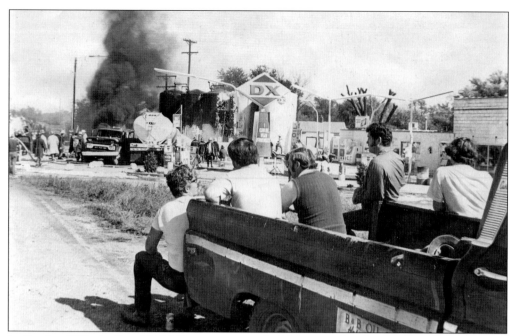

In October 1973, the B and B Oil Company in nearby Holt erupted in flames. Just the previous day, the fire department had worked tirelessly at sandbagging the swelling Missouri River. Volunteers and professional firefighters alike are called upon for a variety of duties in an 80-square-mile area surrounding Kearney. (Courtesy of the Kearney Fire Department.)

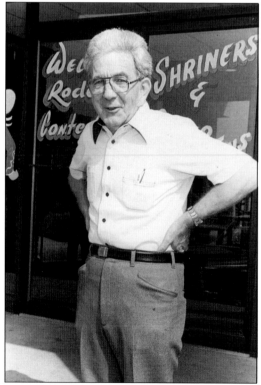

Pictured here in 1986, Kenneth Doss, president of the Kearney Trust Company from 1975 through 1989, worked at the bank nearly his entire adult life. His son Keith replaced him as president. (Courtesy of the Kearney Historical Museum.)

John Ervin, born in 1917 to "Big" John Ervin and his wife, Lettie, worked for 35 years for the Ford Motor Company. He served the town of Kearney on the Zoning Board, the Board of Adjustments, the Board of Alderman, and as mayor in the late-1960s. He was also Worshipful Master of the town's Masonic Lodge No. 311 A. F. and A. M. (Courtesy of the Kearney Fire Department.)

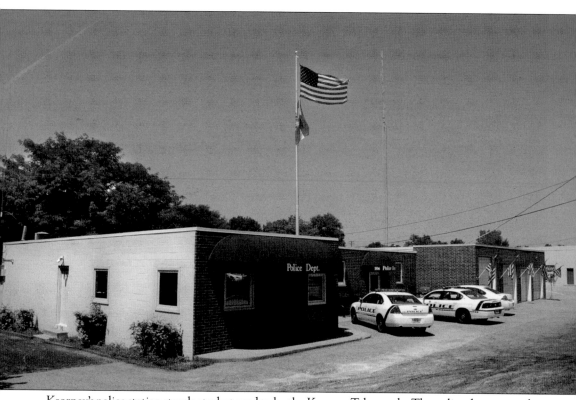

Kearney's police station stands at what used to be the Kearney Tabernacle. The police department has had many additions built onto it over the years. (Courtesy of the Kearney Fire Department.)

Six

KEARNEY FACES THE FUTURE

In 2006, as Kearney celebrated its Sesquicentennial, its confidence was palpable. The town had capitalized on its closeness to Kansas City and could boast of being a wonderful community with just a short commute to downtown Kansas City. Today Kearney maintains its rural nature, but its farmers and ranchers are increasingly becoming commuting teachers, executives, bankers, bookkeepers, engineers, and lawyers looking for a peaceful place to call home.

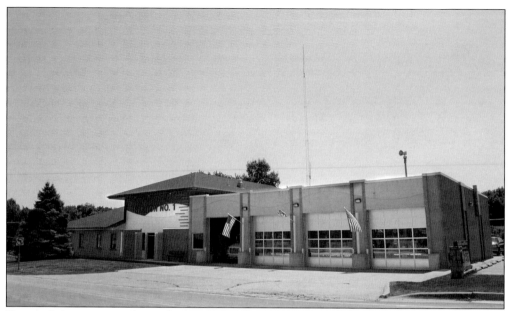

Kearney's fire station is located across town from the police station, but the two departments are in constant communication. Modern technologies can never entirely replace courage and persistence in fire and police work, but Kearney fire and police chiefs are always looking to use the latest innovations. (Courtesy of Edwin Seymour.)

Kearney's school population has exploded, and the town now boasts four elementary schools, a middle school, a junior high school, and a high school. The town has been awarded the Missouri Department of Education Distinction in Performance Award. (Courtesy of Edwin Seymour.)

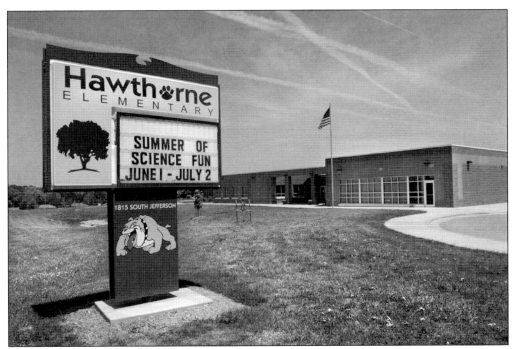

Hawthorne Elementary School is one of four elementary schools serving Kearney, alongside Dogwood, Southview, and Kearney Elementary Schools. The bulldog is still the mascot for the entire district.

The Kearney Village Hall stands directly across the street from the Odd Fellows building and was originally erected for use by the Kearney Community Trust. A resident with a problem or a concern is encouraged to visit the village hall and ask for the village administrator, whose office door is always open.

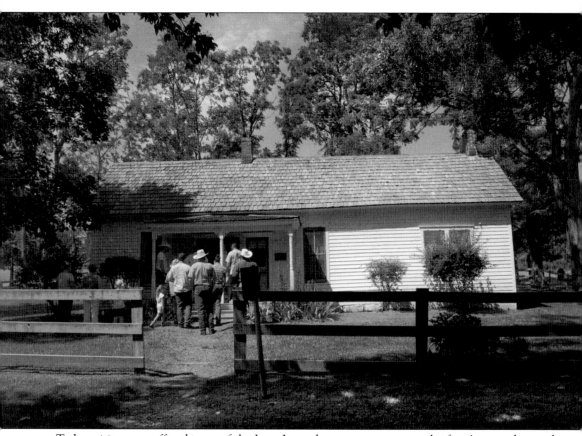

Today, visitors are offered tours of the Jesse James house, a museum on the farm's grounds—and an opportunity to buy souvenirs. An empty grave with a replica of the original gravestone lies in the well-tended garden behind the house.

Founded in 1945 by John McMenamy, Midwest Game Supply is one of the world's largest producers of dice and other casino necessities. In this photograph, longtime employee Marla Pham uses an epoxy-based paint to create the white dots on dice. Kearney is home to a variety of midsize businesses that are able to do business all over the world due to the Internet and more efficient shipping methods.

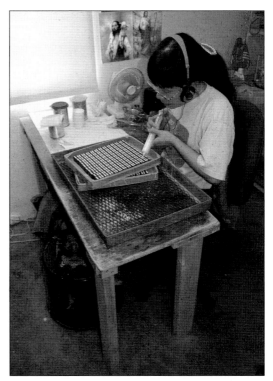

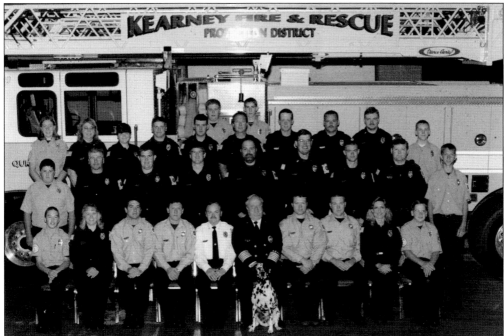

In October 1999, the Kearney Fire and Rescue Protection District posed for a 50th-anniversary group portrait. Included in this picture is Shadow, a Dalmatian who lived in the firehouse. Shadow was taught to "stop, drop, and roll" in order to train children what to do in the event of a fire. (Courtesy of Kearney Fire Department.)

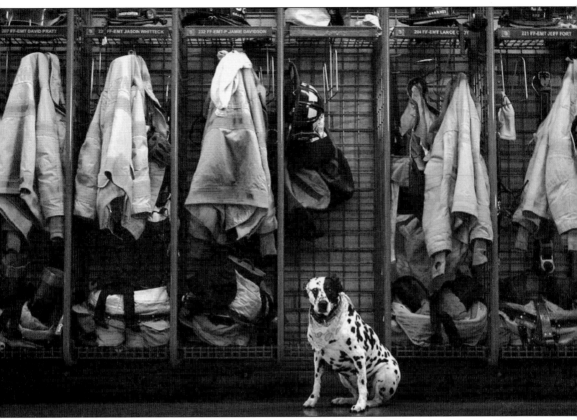

Shadow lived and worked at the Kearney firehouse during the late 1990s and into the present century. Her father, Sparky Blue Chex, also worked for the Fire Department. (Courtesy of the Kearney Fire Department.)

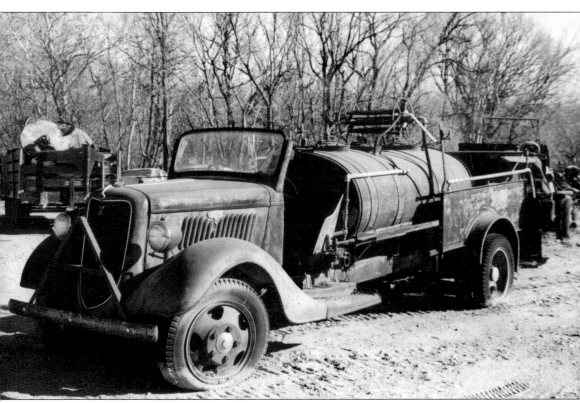

The town's first fire truck was found abandoned in Ole Bill's Museum and Junkyard in nearby Liberty. In 2003, Kearney's fire and police departments joined to restore this piece of Kearney history with a grant from Kearney Commercial Bank. The bank recognized a piece of the town's heritage, and the project brought together the best minds of the fire and police departments. (Courtesy of the Kearney Fire Department.)

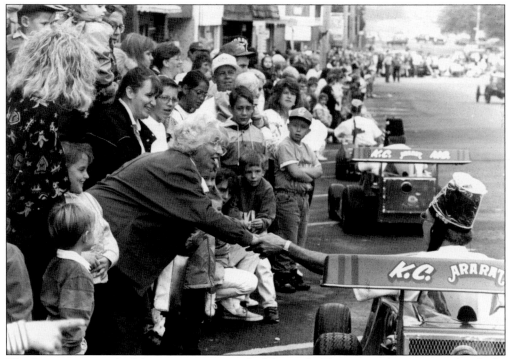

The Sesquicentennial celebrations were a wonderful time for Kearney residents to give thanks for their community, and the celebration's parade was especially well attended. Here a Shriner from Kansas City shakes hands with an admirer. (Courtesy of the Kearney Historical Museum.)

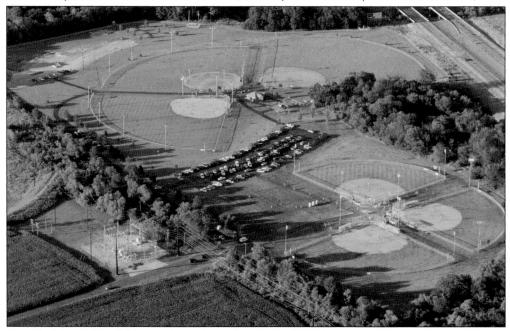

The Mack Porter Playfields complex includes three lighted 200-foot baseball diamonds, two 300-foot lighted diamonds, and one regulation-sized baseball field for daytime use. The playfields are named for a longtime park district board member. (Courtesy of the Kearney Parks Department.)

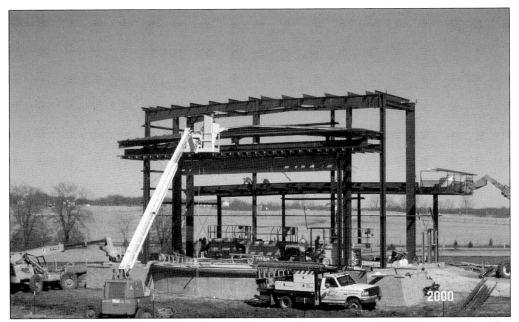

The Kearney Amphitheater, shown here at the start of construction in 2000, was built on the 134-acre Jesse James Park on the outskirts of town. Tough times required a visionary mayor to see the project through to completion. (Courtesy of the Kearney Parks Department.)

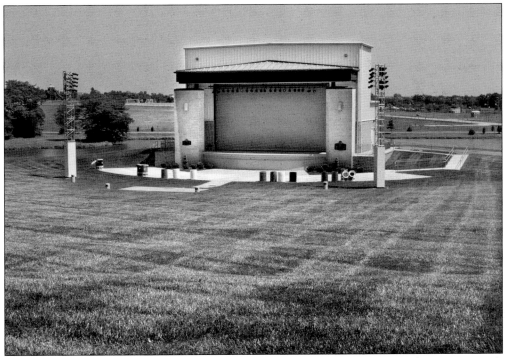

Completed in 2008, the Kearney amphitheater is a perfect place to enjoy an outdoor concert with family and friends. During the Jesse James Festival, world-class acts perform on its stage.

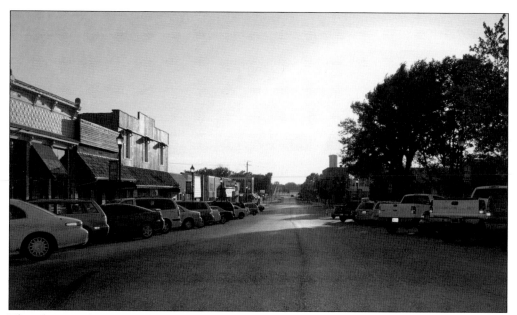

This photograph captures downtown Kearney at sunset. Many modern amenities make the lives of its residents easier, but Kearney will always maintain its hardworking-but-friendly attitude. In Kearney, a visitor is only a stranger until the first hello.

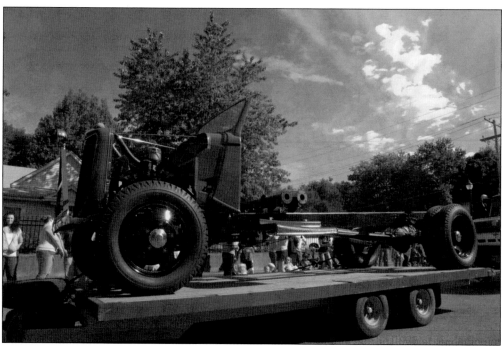

Kearney's fire and police departments are working together to restore the town's original fire truck. In this photograph, the truck is towed in display during the Jesse James Festival parade.

Just a few steps away from downtown is a reminder of what the area could have looked like a century ago. It is not hard to imagine listening for the sounds of galloping horses and hearing the frantic cry, "Here come the James brothers!"

www.arcadiapublishing.com

Discover books about the town where you grew up, the cities where your friends and families live, the town where your parents met, or even that retirement spot you've been dreaming about. Our Web site provides history lovers with exclusive deals, advanced notification about new titles, e-mail alerts of author events, and much more.

MADE IN THE USA

Arcadia Publishing, the leading local history publisher in the United States, is committed to making history accessible and meaningful through publishing books that celebrate and preserve the heritage of America's people and places. Consistent with our mission to preserve history on a local level, this book was printed in South Carolina on American-made paper and manufactured entirely in the United States.

This book carries the accredited Forest Stewardship Council (FSC) label and is printed on 100 percent FSC-certified paper. Products carrying the FSC label are independently certified to assure consumers that they come from forests that are managed to meet the social, economic, and ecological needs of present and future generations.

FSC

Mixed Sources
Product group from well-managed forests and other controlled sources

Cert no. SW-COC-001530
www.fsc.org
© 1996 Forest Stewardship Council

Find *Your* Place in History.